Fred Martin
Selected Paintings and Studio Notes
January-December 2008

illustrated

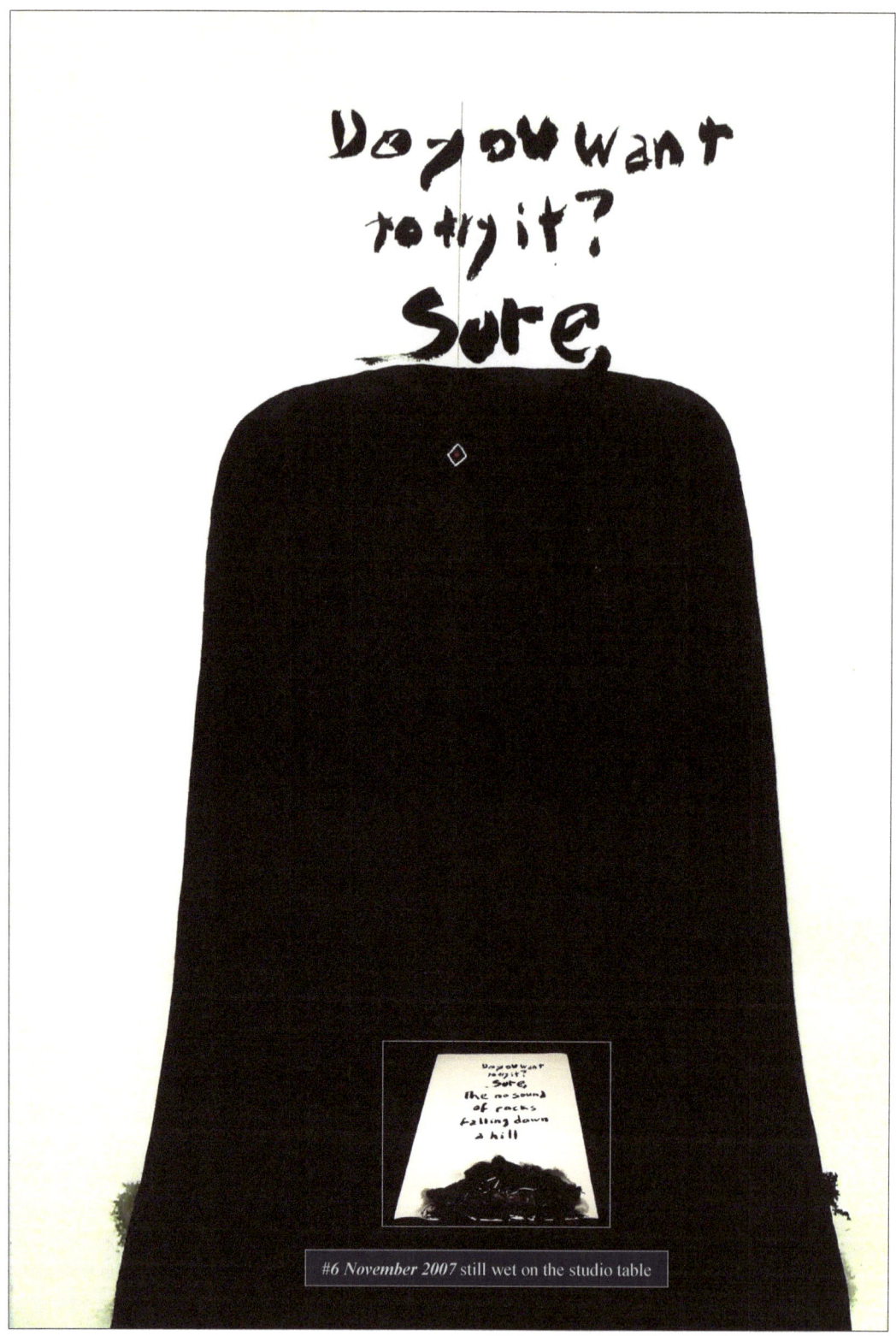

#1 January 2008. 44 x 30 inches.

Fred Martin
Selected Paintings and Studio Notes
January-December, 2008

illustrated

**Green Gates Press
2009**

January 1, 2008.
Lac Ouareau, morning.
Make *#1 January 2008* by "clarifying" *#6 November 2007*.

The notes for *#6 November 2007* were:
"Do you want to try it? Sure, take depression
and dump it on the canvas."

The paint was rocks fallen onto a heap of rotted flesh,
or it was merely lumps of rotted flesh itself (no rocks),
or was the whole thing just a pile of shit with some worms?

I saved "Do you want to try it? Sure,"
and in the darkness of all the rocks and flesh
and wormy shit found a single star of life
high in the earth.

January 4, 2008
Montreal, 1:15 am.
Looking in the mirror before going to bed…
Pale, fading, failing, an old man stumbles on—that's not me.

For my Wife, Stephanie

*Note: All paintings are acrylic on paper,
Sizes vary as noted.*

©2009 Fred Martin
Green Gates Press
#116, 4096 Piedmont Avenue
Oakland, California, 94611.
USA

ISBN 978-0-578-01059-5

As an introduction to this year's work, a note from June 6, 2008.

Montreal, night.
Why do I feel these paintings are going nowhere?

This last few days of looking at them... I said they are "still life"—a few things in a finite space—and thought to myself of the *vanitas* still life so popular in 17th C. images of the dying of beauty conveyed by a fading flower and a bug, maybe together with a watch and a skull. The paintings all had the message of fading and death; the objects said it and the people knew it. Where the skull, the watch or the buggy flower were in the visual focus of the *vanitas*, my paintings have a brief sentence or sentence fragment. The *vanitas* said its message when we saw it then because we already knew what it was; the *vanitas* when we see it now is only a still life and art historians must tell us what it used to be about. My paintings[1] tell my message to your face—see them once and you've heard it and they're over.

Is that why I think they're over? Yet, I don't know how to make anything else.

It goes back to when I was a student at Berkeley. It's not painting but literature if you have words on it. *Le Journal* was OK because Picasso used it as a visual motif and it was a foreign language and no one knew what it meant anyway—and as for all those poems and inscriptions on Chinese paintings, who in my Berkeley Art Department milieu ever saw any of those? My professors taught and I learned that painting is sentimental if the sentiment is more powerful than the form—a Hallmark Valentine card is one example, another was a late 19th C painting I saw once of a shadowed room with a few people (Bohemians obviously) lying around and listening to someone in a shaft of light playing a violin. The painting was titled "Beethoven" and was surely kitsch...unless you had been there and remembered.

So, these works of mine now are "literature" (you can read the words in English) and "sentimental"—unless you have been or are there now.

Well, that's it—there's never a turning back when you've fallen off a cliff.

Just like it was for me in the 1950's-60's, except then I was full of the innocent self confidence of youth, whereas now I have sixty years of experience in the world. And as for falling off a cliff, in youth I was so full of myself I didn't know I was falling; whereas now in old age I'm too weak to grab the few scraps of tree roots and grass that stick out on the way down. (And, yes, I'm still too full of myself to think I need them).

Late night.
Find my way, find my way...
How was it before? I guess these works now are for me where the 1958-62 collages were. I was finding the symbols of that time of my life, and it was only after that could I perceive the aesthetic beauty of the world and make the Asia pastels.

But the time of life of old age? It took me almost fifteen years to get from the cock frenzy of the late 1950's "From a spot of spit" paintings to the 1973 pastels of the Shwe Dagon. Have I the fifteen years left it might take to get from the frenzied aesthetic of age and death in my work now to whatever serene aesthetic I might find fifteen years from now?

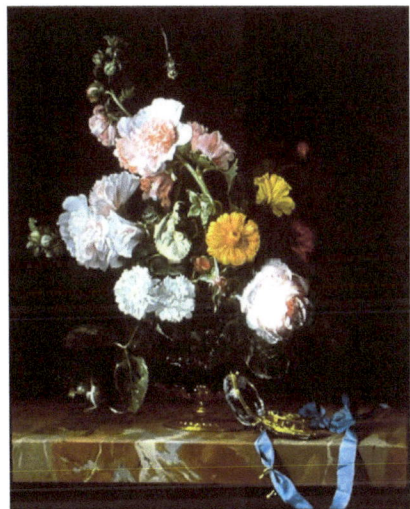

Van Aelst: Flowers, after 1650

[1] I will not call these works of mine "collages." People make pictures—paintings—images—out of colored stuff on paper, canvas or whatever, I make images out of colored bits of paper on paper. Sure, I use paste (soft gel) to hold my colored papers down, other artists use the gel to hold the pigment down. Mine are not "collage" in the sense of the "bricolage" bits of cultural wreckage fallen together; mine are "paintings"—objects of fading and dying to remind, to mourn and to honor time's passing.

January 9-16, 2008
Montreal, late night each night.

#9 August 2006. 44 x 30 inches.

I used a grid to cut all of *#9 August 2006* into nine inch squares. I then chose the squares with the most in them to mount on 15 x 11 inch sheets of Somerset off white printmaking paper, and wrote on each of the larger sheets what the nine inch square told me. I did this every night until I had made ten of them (*#s 4a-j January 2008*) and all the squares that had anything had been used up.

January 9-16, 2008
Montreal, late night.

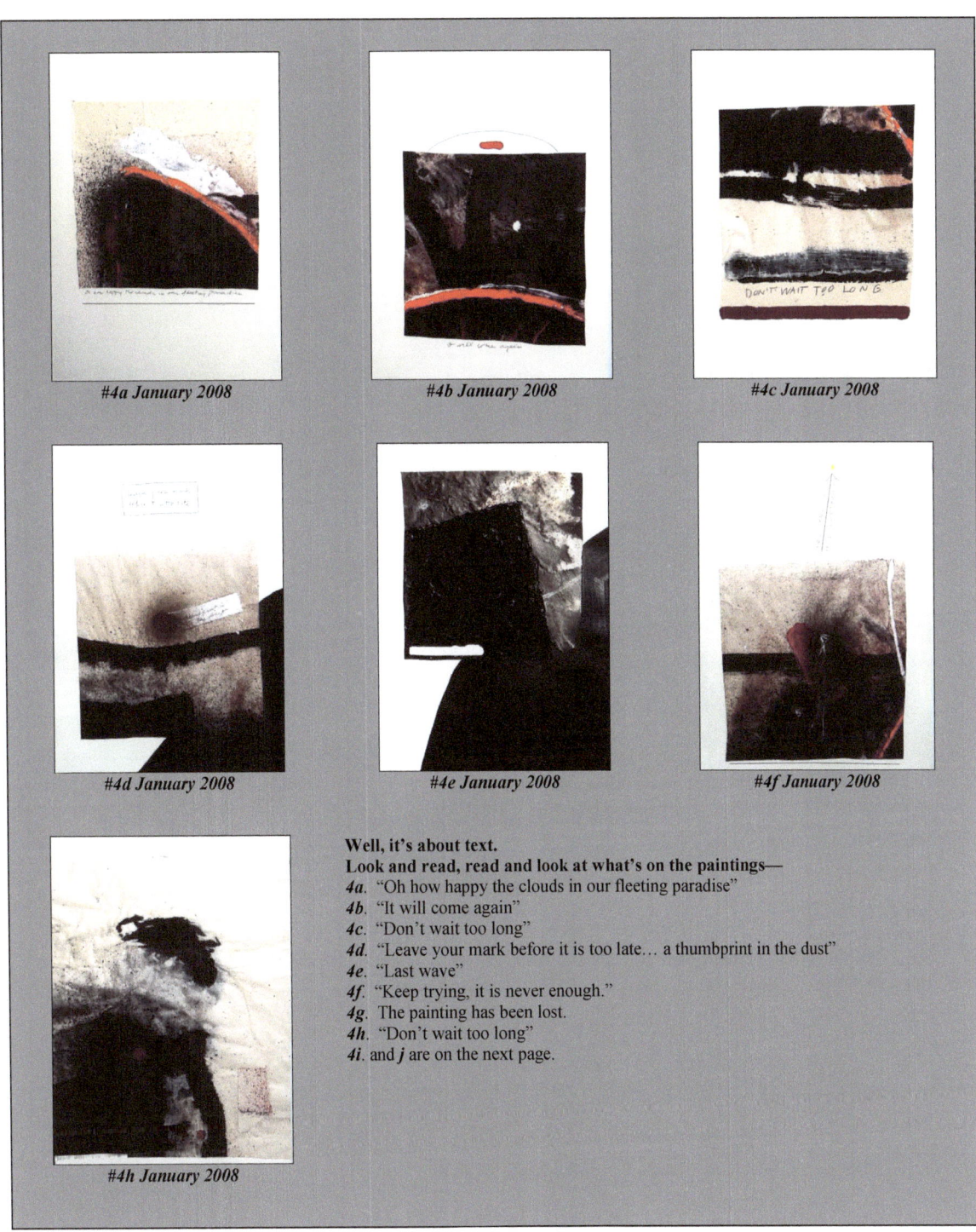

#4a January 2008 #4b January 2008 #4c January 2008
#4d January 2008 #4e January 2008 #4f January 2008
#4h January 2008

Well, it's about text.
Look and read, read and look at what's on the paintings—
4a. "Oh how happy the clouds in our fleeting paradise"
4b. "It will come again"
4c. "Don't wait too long"
4d. "Leave your mark before it is too late… a thumbprint in the dust"
4e. "Last wave"
4f. "Keep trying, it is never enough."
4g. The painting has been lost.
4h. "Don't wait too long"
4i. and *j* are on the next page.

#s *4 a-h January 2008*. Each 15 x 11 inches made from fragments of *#9 August 2006*.

January 15 and 16, 2008.
Montreal, late nights.

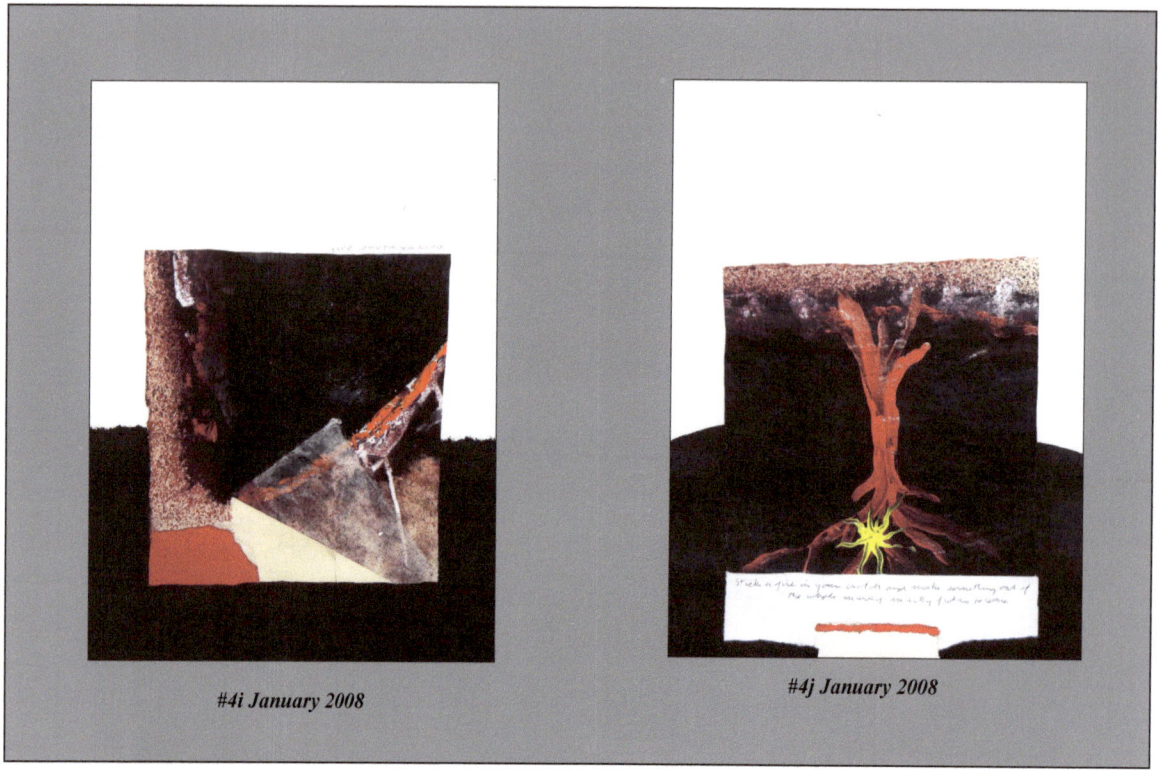

#4i January 2008 *#4j January 2008*

January 15, make *#4i*, and January 16 make *#4j January 2008* out of *#9 August 2006*.

The original text of *#4j* was "Stick a Goddamned fire in your balls to make something out of your whole murky mucky future to come." But, I tamed it to make it showable. Now it says, "Stick a fire in your crotch and make something out of the whole murky mucky future to come." The change was a failure of nerve and treason to myself.

January 16-19, 2008
Montreal, afternoon.
I learned from Gerhardt Richter's stained glass window for Cologne cathedral that when God is gone, there remains the shimmer of sensation from which He had been constructed.

And so for me to learn my lesson from him:
Break them up; let them loose for speaking again…
And so I decided to continue to cut up into more or less nine inch squares all but one of the August 2006 rice paper paintings.

January 19, 2007.
Lac Ouareau, afternoon and night.

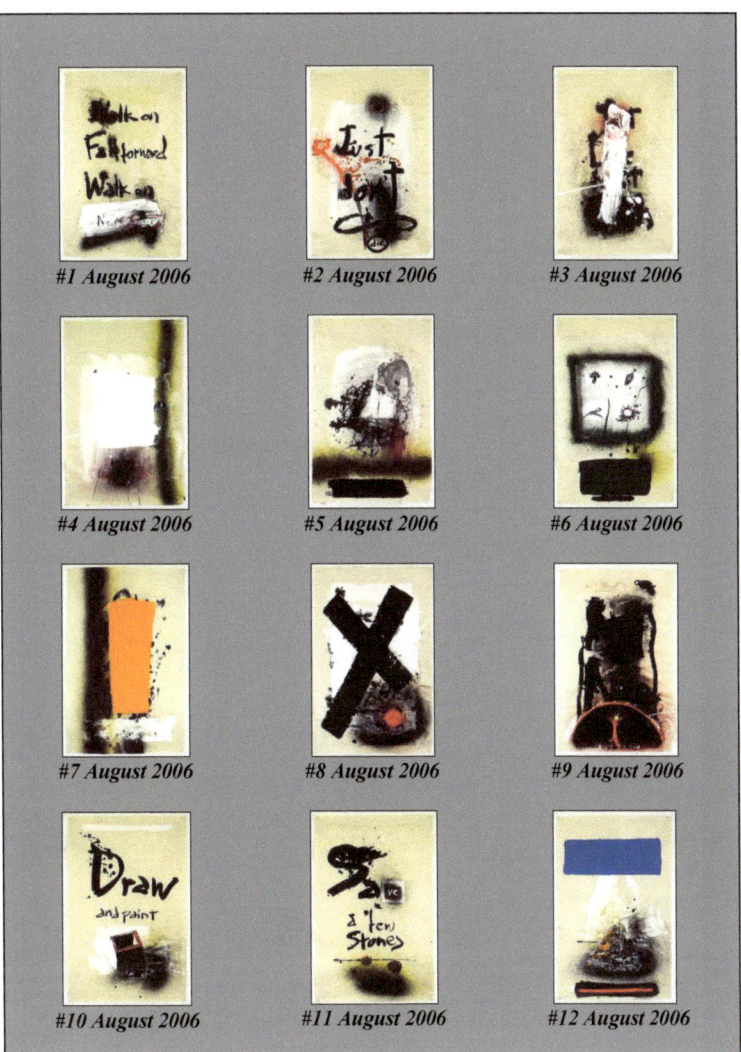

#s 1-12 August 2006. Each 44 x 30 inches.

All except *#5* were finally cut up on the nine inch grid
to make most of the work January through April, 2008.

January 17, 2007.
Montreal, night.

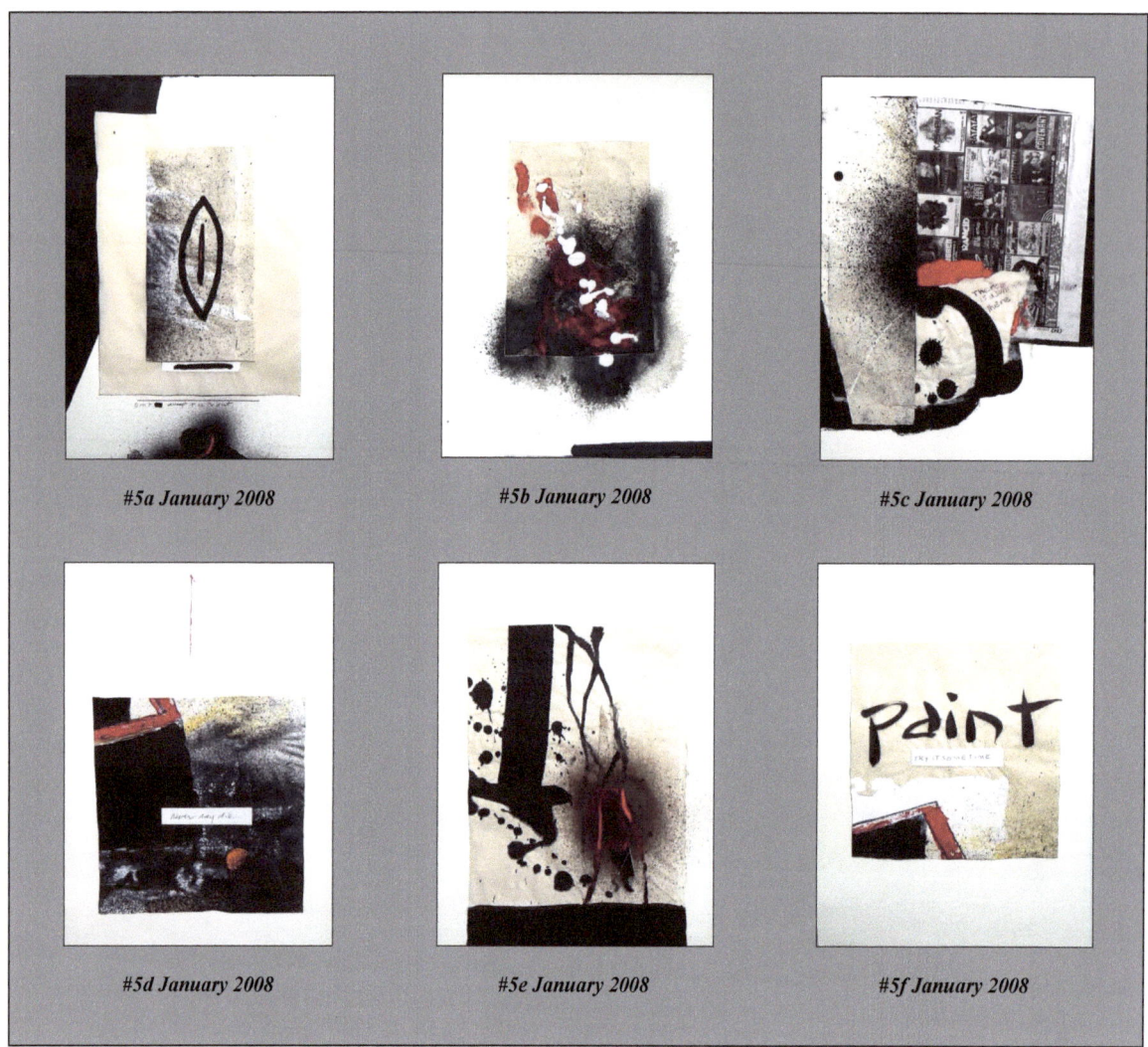

#s 5 a-f January 2008.

Remembering the old days of Kandinsky and The Spiritual.
But, then, that didn't work either.

On the painting to start—	*On the painting at the end—*
5a. 'Nothin's cummin'… dump it in the dirt"	"Don't dump it in the dirt"
5b. "Do it in life, forget art about it."	Text gone
5c. "There is a sunrise there" [and it's in the balls]	"There is a sunrise there"
5d. "Never say die"	"Never say die"
5e. "His is blood in the gutter"	Text gone
5f. "Paint—try it sometime"	"Paint—try it sometime"

It only finally adds up to how we leave our marks in the dust on our way to eternity.

Early February, 2007.
Oakland, very late night.

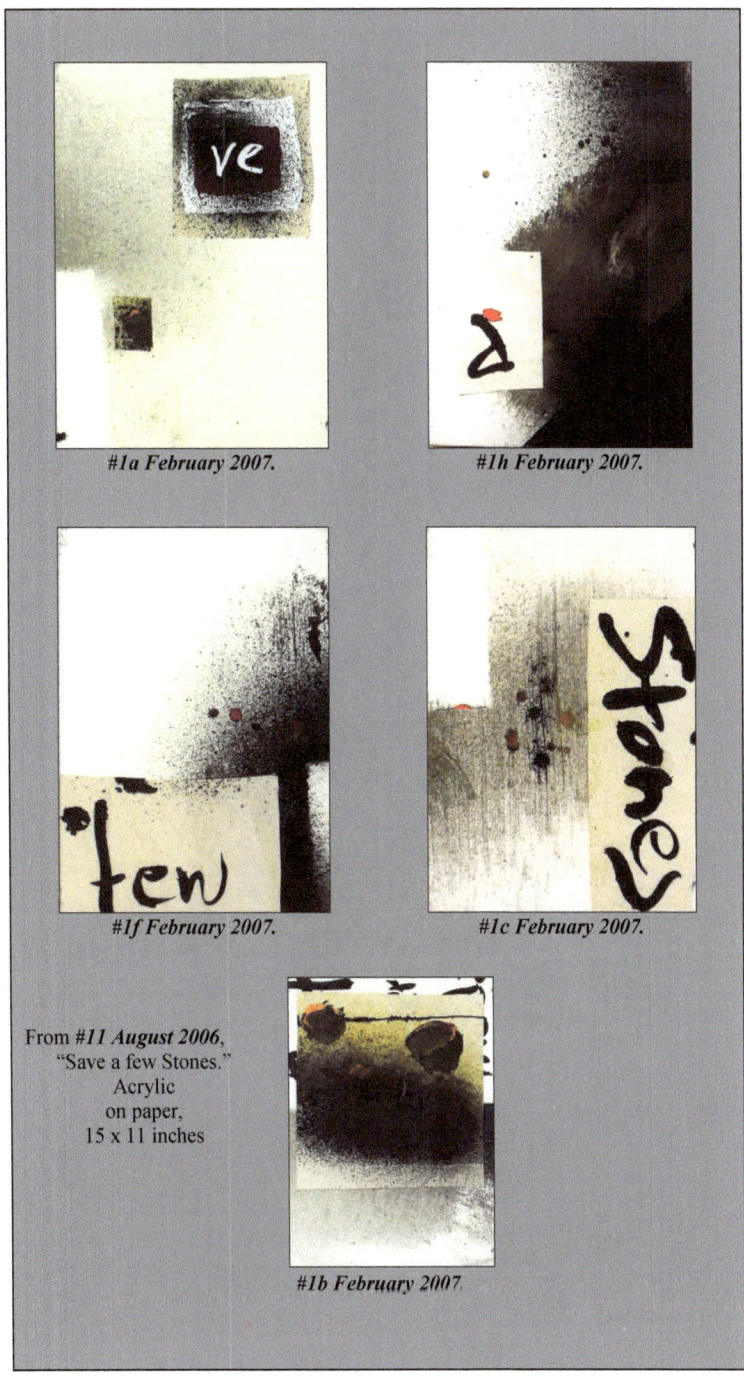

Early February, 2007.
Oakland, very late nights.

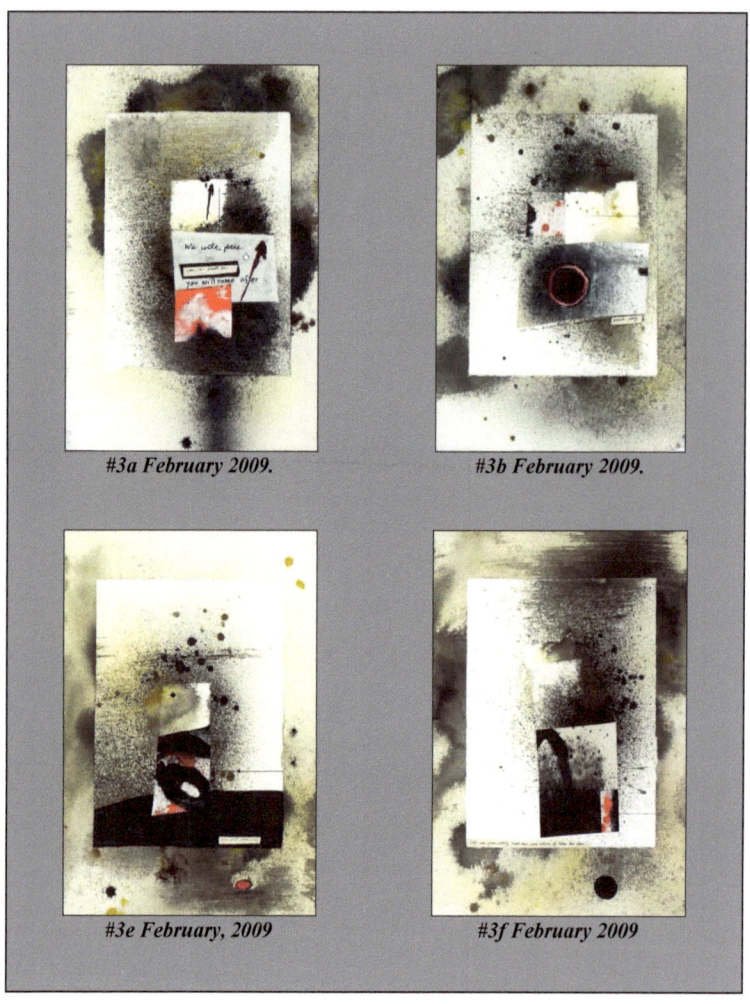

#3a February 2009. #3b February 2009.
#3e February, 2009 #3f February 2009

#s 3a-h February 2008—*This and facing page*
each 22x15 inches.

February 18, 2008.
Oakland, late night.
When the aesthetic experience of spit, blood and cum
smeared shining in the gutter is the only one worth saving…
and if anyone were ever to show, buy, praise or even "groove" on such works
what does that mean contemporary culture means?

Ask the Cultural Studies people.

Early February, 2007.
Oakland, very late nights.

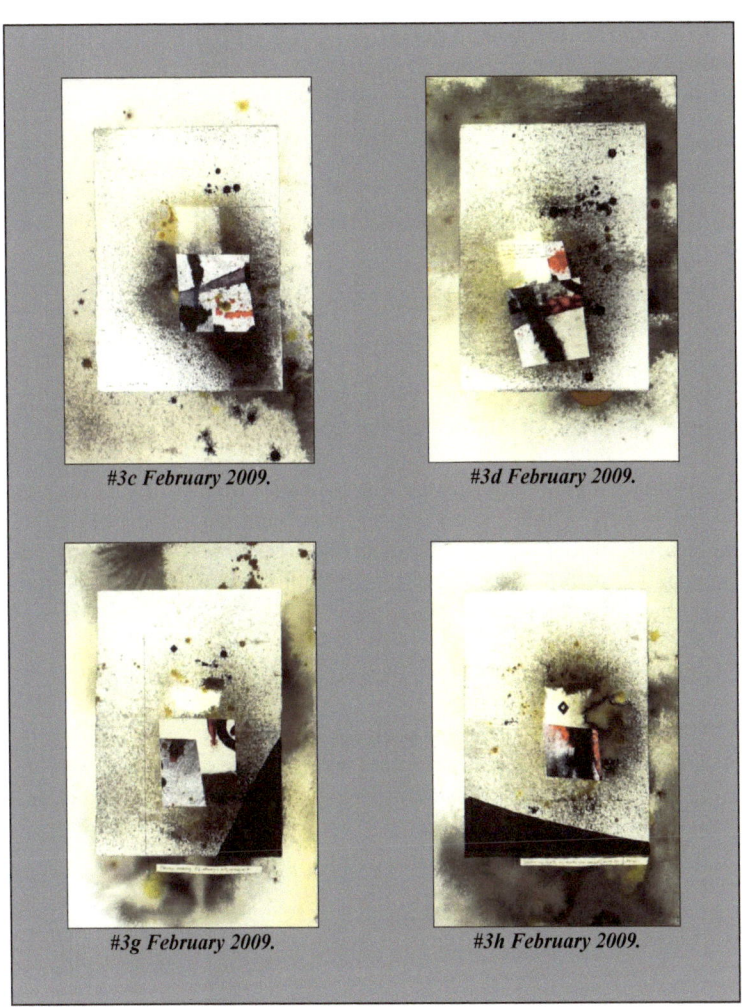

#3c February 2009. *#3d February 2009.*

#3g February 2009. *#3h February 2009.*

On paintings #s 3a-h February 2008—
3a. "We will pass—was, is, shall be—you will come after"
3b. "all the knowledge, hope and fear—each day"
3c. "Was, is, shall be"
3d. "Make the words so all the past they write will last through all the future to come."
3e. "Stele still standing"
3f. "Tell me your story, tell me your story of how too far…"
3g. "Passing, passing, it's always only going on to…"
3h. "Little King Death, we make you small so we be large."

March 1, 2008.
Montreal, very late night.
So many years I've been working, and I really don't know what I'm doing and that's a fact.
So far as I know, no one has been here before and so there are no guides.
Kandinsky and Klee, yes and no. No one at Berkeley or CSFA and in all the art mags since, no one.
And as for the latest shows in NY, neither the Courbet nor Poussin shows at the Met nor the Whitney Biennial show me the way.

So, is this work "original?" Originality is only if the work is useful for others in their work. Something different that's not useful is only freaky. This work of mine is not useful for others in their work and so it is not original but freaky.

March 1, 2008.
Montreal, 3am.
And then the desperation comes, thinking about world history, the hopeless wreckage—just now the Palestinian/Israeli ruin, each the puppet of some other—Hamas of Iran, the US of Israel…

And all the stupid shit of Afghanistan… as they said between lipstick and cosmetics on the CTV news, the Russians had 160,000 soldiers there, Canada only 2000… everyone has lost there since the fall of the Kushans in I guess the mid 3^{rd} C. And Bagram, where the US maintains the prisons now in the name of NATO, was the site of the tallest stupa/pagoda in the world, gold plated until the lightning struck and burned it down sometime some 1900 years ago—like happens to the US now.

And I remember the bronze plaques to long gone British regiments in the Khyber Pass…[1]

Why does this happen over and over? At least, Alexander made it stick for a century or two 2,300 years ago. And the poor little Gandhara relics of the work of Greek sculptors trying to give images to heretic Hindu visions, also lost; and the largest Buddha in the world at Bamiyan, gone in the latest my god is the only god and so I'm blowing up your god and killing you right now.

3.30 am.
Ok, let's go to bed. I will never get out of this drunken cycle of the perpetual wreckage of the world.

Yes, I must stay up all night.
World history, that really was a wreck.
[Sure, "Wreck" has been repeated too often. But what worlkd (that's world + wreck + word) is there?]

Bagram and the Kushan Empire…
Bagram and the US Empire and its prisons there…
The George W. Bush wreck of everything I thought America stands for.

[1] From the New York Times, Sunday, January 25, 2009, Page one, "Fearing Another Quagmire,"
by Helene Cooper, the epigraph—

"When you're wounded and left on Afghanistan's plains
And the women come out to cut up what remains
Jest roll to your rifle and blow out your brains
An' go to your Gawd like a soldier."
　　　—Rudyard Kipling, "The Young British Soldier," 1892

March 2, 2008.
Montreal, night.

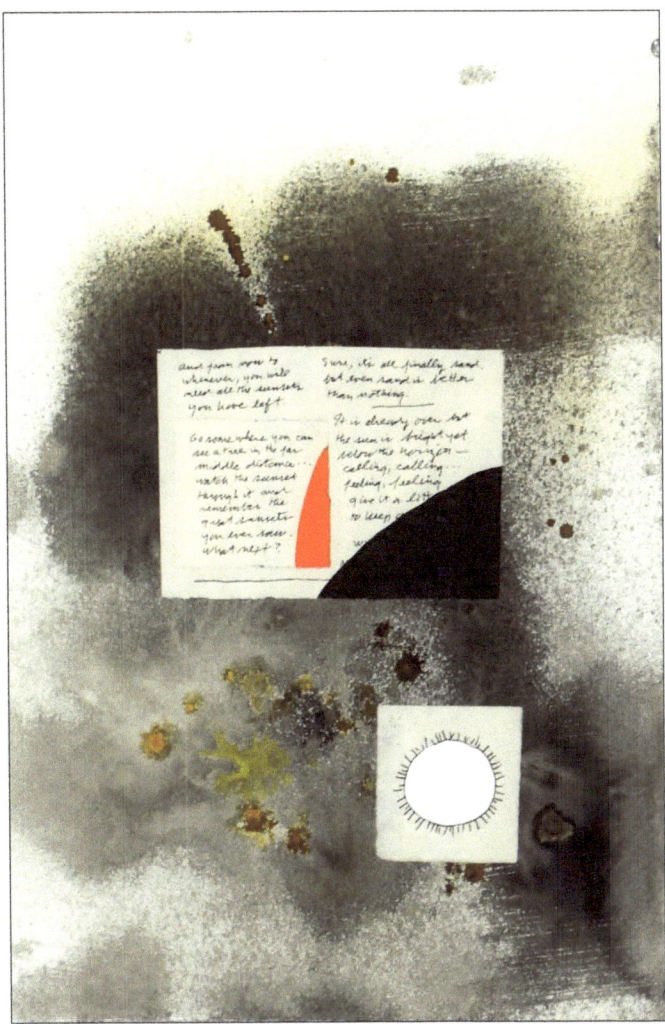

#1a March 2008. 22x15 inches.

Planning the painting—
Finding your way slowly,
Finding your way slowly—
How strange it would be
If these were to turn out to be
Your last things.

And on the painting—
"And from now to whenever, you will need all the sunsets you have left.
Go somewhere you can see a tree in the far middle distance… watch the sunset through it and remember the great sunsets you ever saw—what next?
Sure, it's all finally sand, but even sand is better than nothing.

"It's already over, but the sun is bright yet below the horizon—
calling, calling… feeling feeling…
give it a little… to keep…"

March 3, 2008.
Montreal, night.

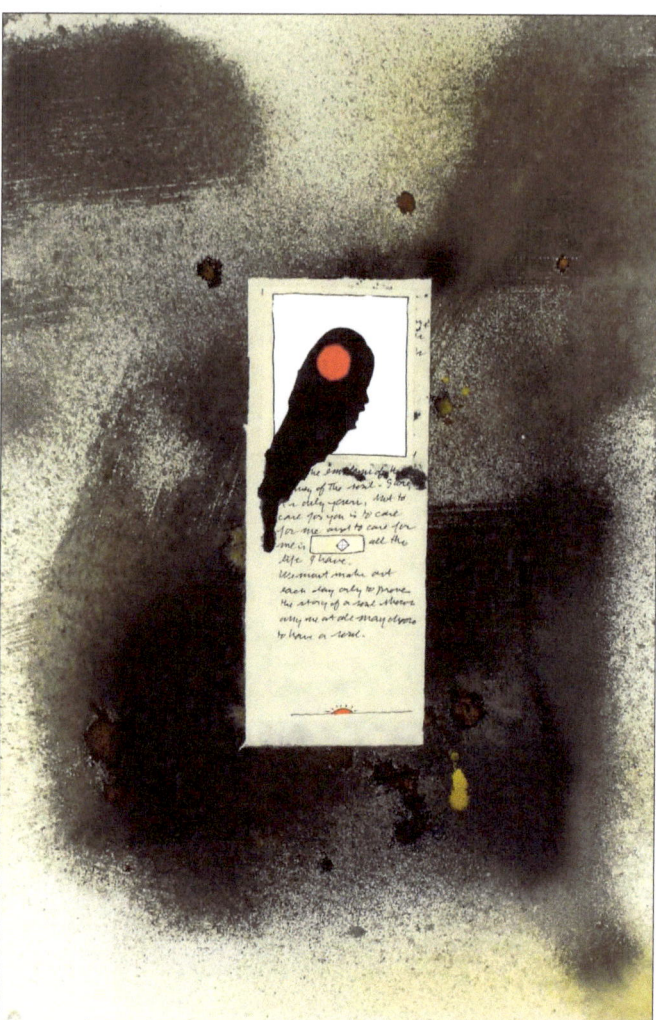

#1b March 2008. 22x15 inches.

On the painting—
"…the emblems of the way of the soul—
Sure, it's only yours, but to care for you is to care for me and to care for me is to care …
for all the life I have

"We must make art each day only to prove why the story of a soul shows why
we at all may choose to have a soul."

March 3, 2008.
Montreal, night.

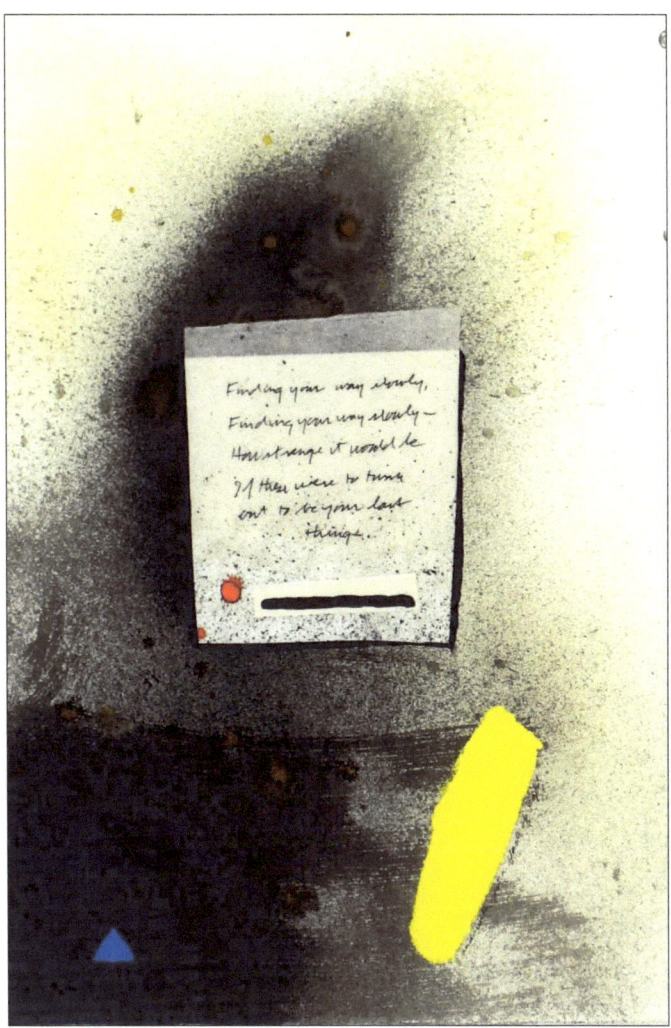

#1c March 2008. 22x15 inches.

On the painting—
"Finding your way slowly,
Finding your way slowly—
How strange it would be
If these were to turn out to be
Your last things."

"and with just a flash of light"

March 10, 2008.
Lac Oaureau, late afternoon.

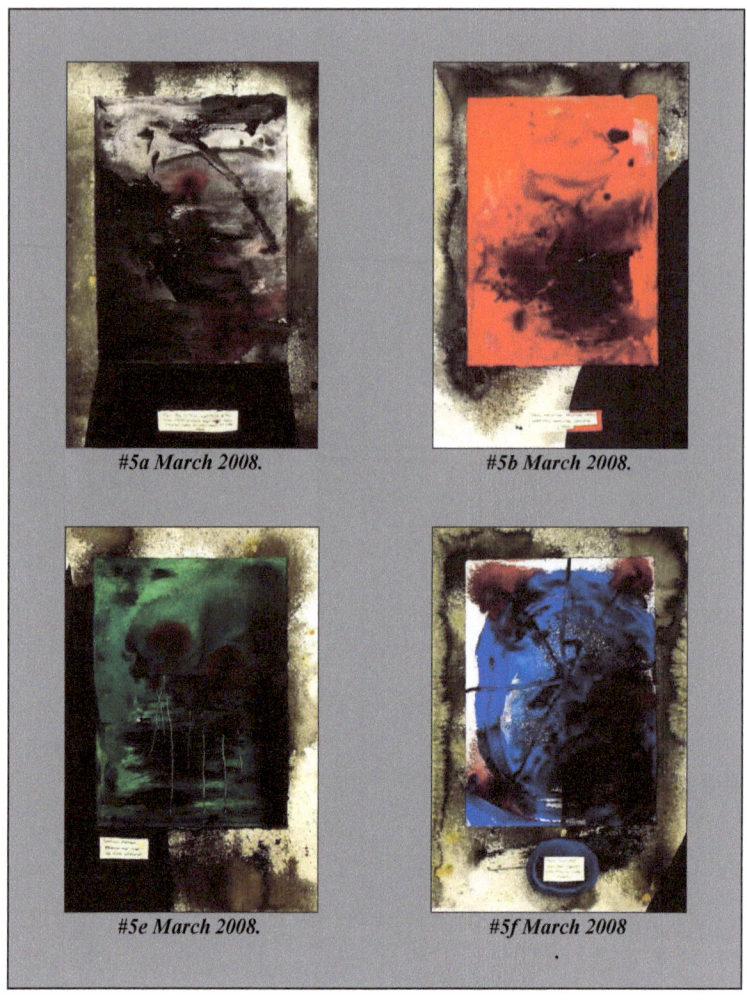

#s 5a-h March 2008. each 22 x 15 inches.
(Private Collection, San Francisco)

I wrote the texts out of the last month or two of miscellaneous texts,
and then made the paintings without considering the texts.
The texts were about living and dying; the paintings were about the "color sounds" of the rainbow.
The problem has been how to get the texts—the words of the song—somehow into the image
that is the music—not even considering the questionable literary quality of the texts…
Later on, as I worked on all of them at once, I noticed the real key of the whole theme is
"Where the blood goes."

And then, at the end of working came "Put the darkness at the end in each—
say go your way, go your way, go your way…"

March 10, 2008.
Lac Oaureau, late afternoon.

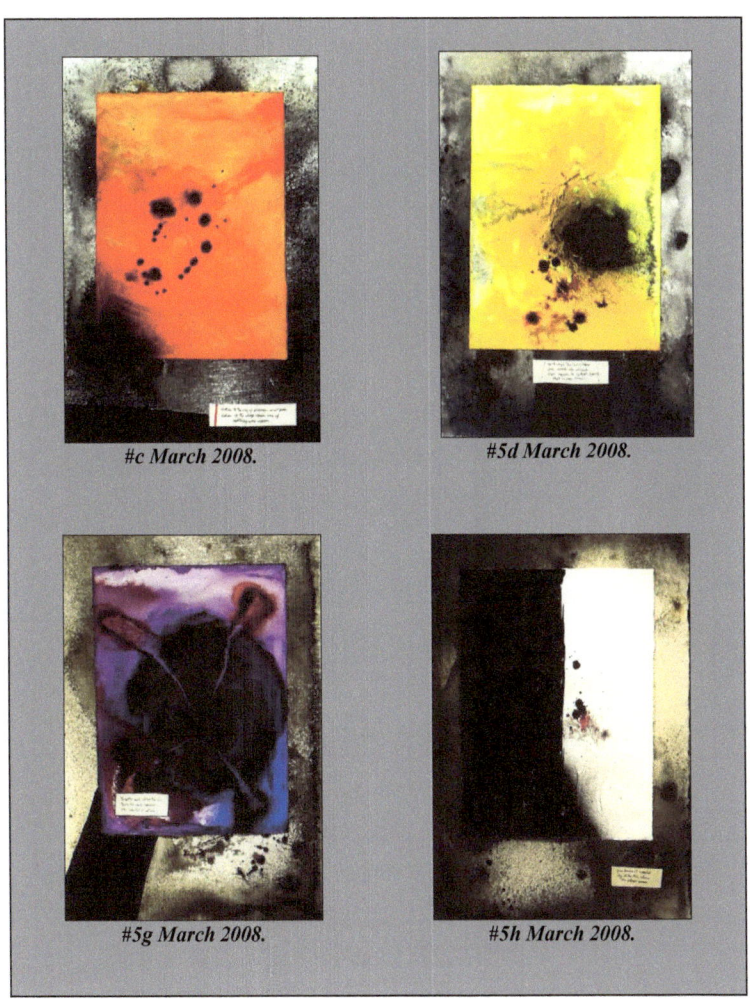

#c March 2008. #5d March 2008.

#5g March 2008. #5h March 2008.

On the paintings—
5a. "The rainbow sound of all of us.
From thin to thick and thick to thin,
from light to dark and back again.
Hear the sound, write the words—
the rainbow song of all of us."
5b. "Today, tomorrow, tomorrow, today, yesterday,
neverday, everday, now."
5c. "Listen to the cry of pleasure and pain,
listen to the deep down cry of nothingness again."
5d. "Up through the rainbow our souls do climb,
to fall again to rotted earth that is our time."
5e. "Seed and blossom, blossom and seed—our life lives eternal"
5f. "Aspire and fail, and fail, aspire—our turning circle always"
5g. "Breathe out, breathe in. breathe out again.
The world breathes us."
5h. "You knew it would be like this, but it never is."

March 11, 2008
Lac Oaureau, night.

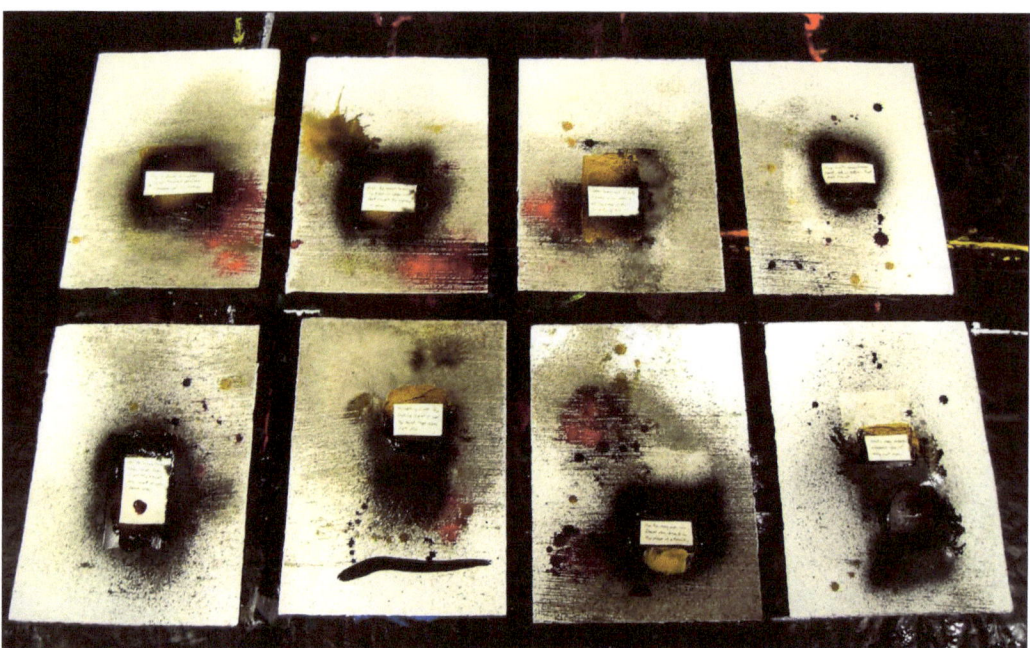

#s 6a-h March 2008. Each 22 x 15 inches.

Make the "backings" for *#s 6a-h*. The aesthetic principle is, lay a strong form over a weaker, ambiguous one, and the strong grabs and integrates the weaker into itself. The "backings" are the weak.

March 12, 2008.
Lac Oaureau, night.
Paste the strong colored ones onto the ambiguous gray ones.

March 13, 2008.
Lac Oaureau, morning.
Laid out on the studio table, left to right and top to bottom, *#s 6a-h 2008.* Each 15 x 11 inches.

On the paintings—
6a. "Try to make it deeper, so all the past will last through all the future"
(Given to Professor Pan Gongkai, President Central Academy of Fine Arts, Beijing, PRC.)
6b. "Make the paint so all the past it holds will last for all the future to come."
(Given to Mr. Yeh Chizhang, Hangzhou, PRC, my first China connection in 1985-6.)
6c. "Your every act is only a page in the book of all the pages of the infinity of life."
6d. "King Death sometimes hurts only a little. But don't try it."
6e. "All the knowledge, hope and fear of all the world are met in you each day."
(Given to Professor Wei Ersheng, President Lushun Academy of Fine Arts, Shenyang and Dalian, PRC.)
6f. "The falling light, the fading light, is yet the light that does not die."
6g. "On the way out, we leave our mark in the dust of eternity."
6h. "Never say never because you'll only get ever."

March 27, 2008.
Oakland, early morning.
Lost now, lost then
Lost first, lost last
Lost here, lost there
Lost ever, lost never…
NO!

April 4-13, 2008.
The April China trip.
April 4-6, Montreal to Vancouver to Beijing.
April 6-7, visit Central Academy of Fine Arts, Beijing.
April 8-9, visit China Academy of Art, Hangzhou, for 80th Anniversary of the school
and the International Conference on Art Education in Higher Education.
April 10, visit to Luxun Academy of Fine Arts, Shenyang.
April 11, Shenyang to Dalian to visit Dalian campus of Luxun Academy.
April 12, visit Dalian campus of Luxun Academy
April 13, Dalian to Beijing to Vancouver to Montreal.

April 17, 2008.
Montreal, night.
What you need to do now in art, Fred, is move on, finding new things, new ways—
Never cease until the brain stops.

Late night
I have no idea how to make it work. No idea.
I can't do it.

April 18, 2008
Montreal, afternoon on the Metro to Atwater to Andrew's gallery.
Method:
First the ground,
stained, fading, dying
Then the clay and the spray of age,
Just drag it, the clawing in the clay
And then the note…

Where to make [to work]…
Where the solitary monk's cell?
Where the far hermitage?
Where the small high room in the night
[This last is the only place available to me, but I can't find it either.]

*

Later, at Andrew Lui's *Han Art Contemporaine* gallery and talking about my recent trip to Beijing, Chloe (who is from Hong Kong) exclaiming of Beijing, "They don't even make noodles right!"

*

April 18 continued in late night.
Shit, Fred…
It's a long way down.
Stop that one—
Never say die.

Thinking about my current painting style and rich aesthetic orchestration…
What more do I need? Certainly not "rich aesthetic orchestration." So, what more do I need? Nothing.

April 19, 2008.
Montreal, early morning.
I will not let me die.

Late night.
Make *#s 5a-f April 2008.* Each 11 x 7.5 inches.

On the paintings—
5a. "I have no idea how to make… No idea how to do it. Follow the seed."
5b. "Finding new things, new ways, never… Finding new ways.
Never cease until the brain stops."
5c. "This rich aesthetic orchestration. What more… You need nothing because you have everything."
5d. "It's a long way… It's a long way down. Never say die."
5e. "When God died, our fingers were stained with His—our—blood."
5f. "NEVER SAY DIE."

April 20, 2008
Lac Oaureau, night.
No—
Not my little notes of flailing, aging, fading and…
But, from the masters who have lasted—

Late night.
Begin *#s 6a, b, c, d April 2008.* Each 22 x 15 inches.

April 19, 2008.
Montreal, late night.

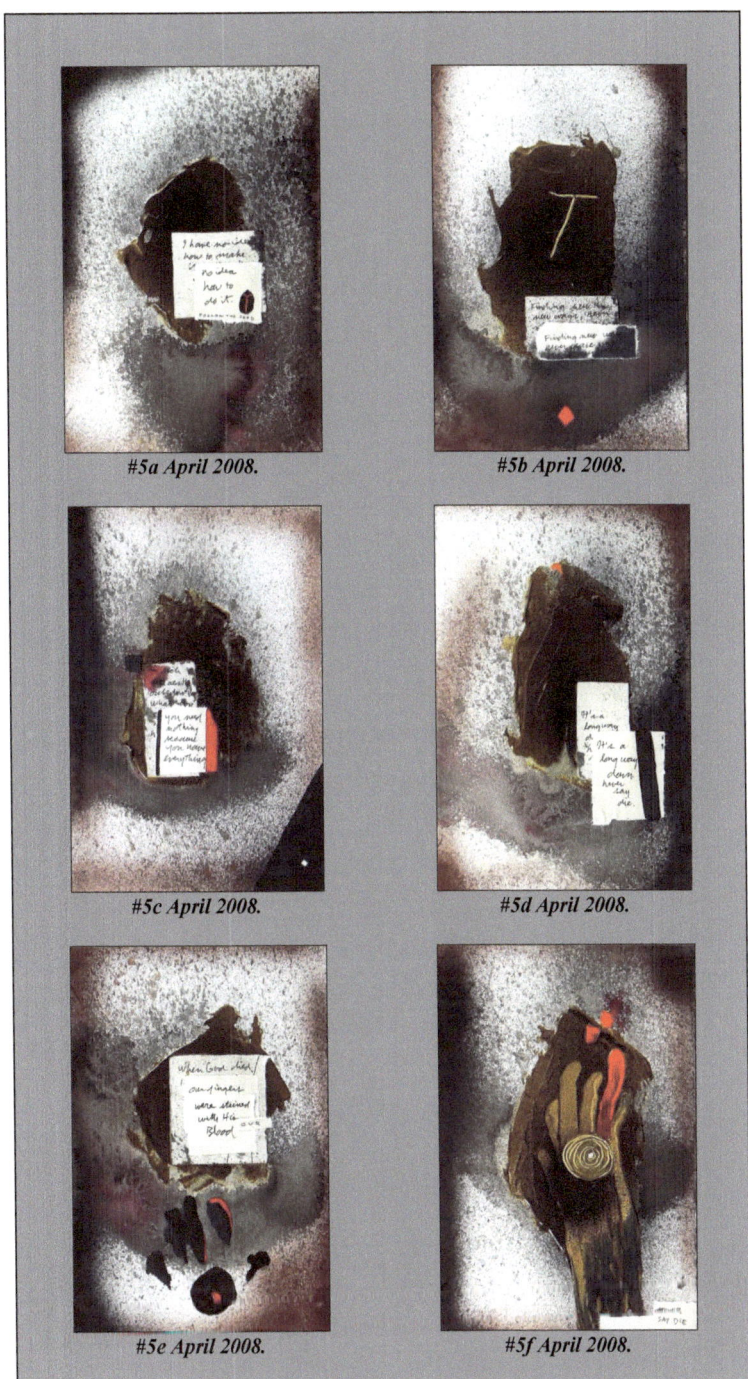

#5a April 2008. #5b April 2008.

#5c April 2008. #5d April 2008.

#5e April 2008. #5f April 2008.

#s 5a-f April 2008. Each 11 x 7.5 inches.

April 23, 2008.
Lac Ouareau, all day.
Complete #s *6a-d April 2008*.

On the paintings—
6a. "Mark them now before their memory is gone.
Memory goes, brain dies, soon enough there's only dust.
Make the monument while you still can."
6b. "Mark memories now before mind is gone.
Mom and Dad, our family, our lives—
Mark and tell, remember, remember,
The story the story the story"
[With a trail to the sunrise]
6c. "Remember" [with the fire of life]
6d. "ALL OVER SOON
Sunset after sunset, again again—
And then one day you'll not have a dawn"

Night.
The world is waiting for the sunrise—so far, mine's been fake.

Hard to get set here now. Space too big and blank.
Just don't have the same old aspiration for grandeur (not that mine were ever that grand).

This afternoon I found an old card with a note:
The old wind
The gray light
Time eats.

I wrote this afternoon's thoughts on the card:
Life hurts
Art's no cure

Things die
And painting gives no immortality.

April 23, 2008.
Lac Ouareau, all day.

#s 6a, b, c, d April 2008. Each 22 x 15 inches.

April 25, 2008.
Lac Oaureau, morning
An Artist's Statement:
And so the painting goes
Step by step, now where, now why, now when?

The highest mountain, the widest plain
The longest river, the deepest sea
The farthest desert or a distant cloud

Step by step, now where, now why, now when?

Note: In youth I was driven by sex, in maturity I worked to build a community in which to live, and now I seek to save what matters for those to come.

April 26, 2008.
Lac Oaureau, all day.
Complete *#s 7a-f April 2008*,. Each 22 x 15 inches,
each with the April 25th "Artist's Statement" for text…

On the paintings—
7a. An artist's statement
with a death star, an orange bar and a white smear.
7b. An artist's statement beginning
"and so we go, step by step…"
and with "on the long spiral against death" and an orange diamond.
7c. An artist's statement ending in a "?"
and on white with an orange square
7d. An artist's statement
With a 1950's sun sign, the death star and "DON'T LET DEATH WIN"
7e. An artist's statement
with a 1950's cock sign, with "EVER SEEK, NEVER CEASE," and an orange diamond.
7f. An artist's statement
with the 1950's cunt sign (with eternity color slit), the death star and a blood red infinity sign."∞" set vertically.

Late morning.
After finishing *7a-f*, I wrote on the original "Artist's Statement" note…
"Unless you risk everything, you'll get nothing."[1]

[1] Note from Monday, May 05, 2008—but then too often you still get nothing.

April 26, 2008.
Lac Oaureau, all day.

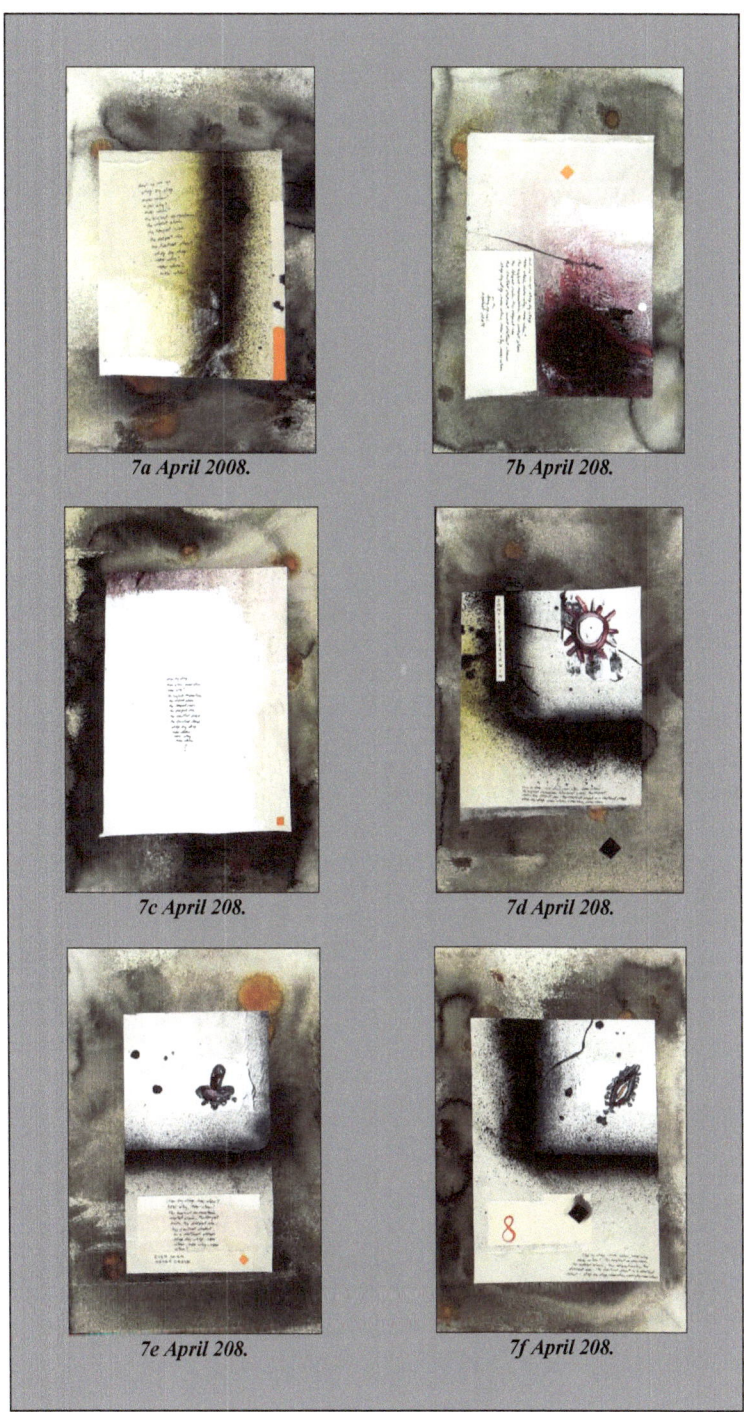

#s 7a-f April 2008.. Each 22 x 15 inches.

May 6, 2008
NYC, morning at the Metropolitan Museum.

Notes from the Poussin show…

On a wall label—
"It is said the swan sings more sweetly when death approaches. I will try to imitate him and work better than ever."—*N. Poussin.*

Cat. 58. A Landscape With Three Monks.
An observation:
So far back from the city and so many dark cliffs and rocks and the monks near us beside a pool fed by a spring from the rocks…

May 10, 2008
Oakland, night.

My New Work and the Avant-Garde
Many years ago I wrote an essay titled *My New Work* for my Art and History column in Art Week. The essay was prompted by the commercial gallery habit then (and now) to title one person shows with the name of the artist followed by the phrase "New Work." The essay pointed out that such a title suggests not only the inferiority of last year's work to this year's, but also that an artist's work over time is like every year's "all new" automobiles and "new and improved" breakfast cereals. Well, an artist's work is not like that; each work is new when you first see it, and so I suggested in the essay that we take our old stuff that no one ever saw or if seen is now long forgotten, write new dates on it for our next show and once again the show is "New Work."

Well, there is another side to the "New Work" phrase, and that, like the new cars and cereals is based on the belief in progress. I think Vasari may have started it when he praised the Florentines' getting rid of the barbaric "Greek Style," or as I used to teach in my art history classes, 13^{th} C. Berlinghieri gave way to 14^{th} C. Giotto and the rest was history. The march of European art 1300-1900 is the march of the conquest of the representation of three dimensional volumes in a three dimensional void. Yes, art has progress and like nations only gets better—or goes down through decadence to revolution and rebirth.

Perhaps the term *avant-garde* mattered a century or more ago when artists were inventing new forms of expression for the new Industrial Age (like the Italian Renaissance artists did for the new Mercantile Age beginning then). But now, when at the most *avant-garde* International Art Conference I've attended in years,[1] the goal was to invent and teach an art form "*interoperable*, like computer programs must be for the internet"—well, as was announced in ARTFORUM more than thirty years ago, "Painting is dead," that is, at the end of its history.

However, the only history of the human soul is we are born, we live, we die. Our fate's the same no matter what our clothes, and some of us care neither for the *avant-garde* nor the cutting edge but for our fate and what we can make of it as destiny. And so for all our work from any time in our long or short lives, when you see it, it's Our New Work.

[1] It was last April at the 80^{th} Anniversary of the China Art Academy in Hangzhou,. Art school presidents had come from all over the world to honor the China Art Academy and to deliver papers on the education of the artists of the future. Everyone was calling our goal "Cutting Edge," *avant-garde* is so passé.

May 15, 2008.
Oakland, night.

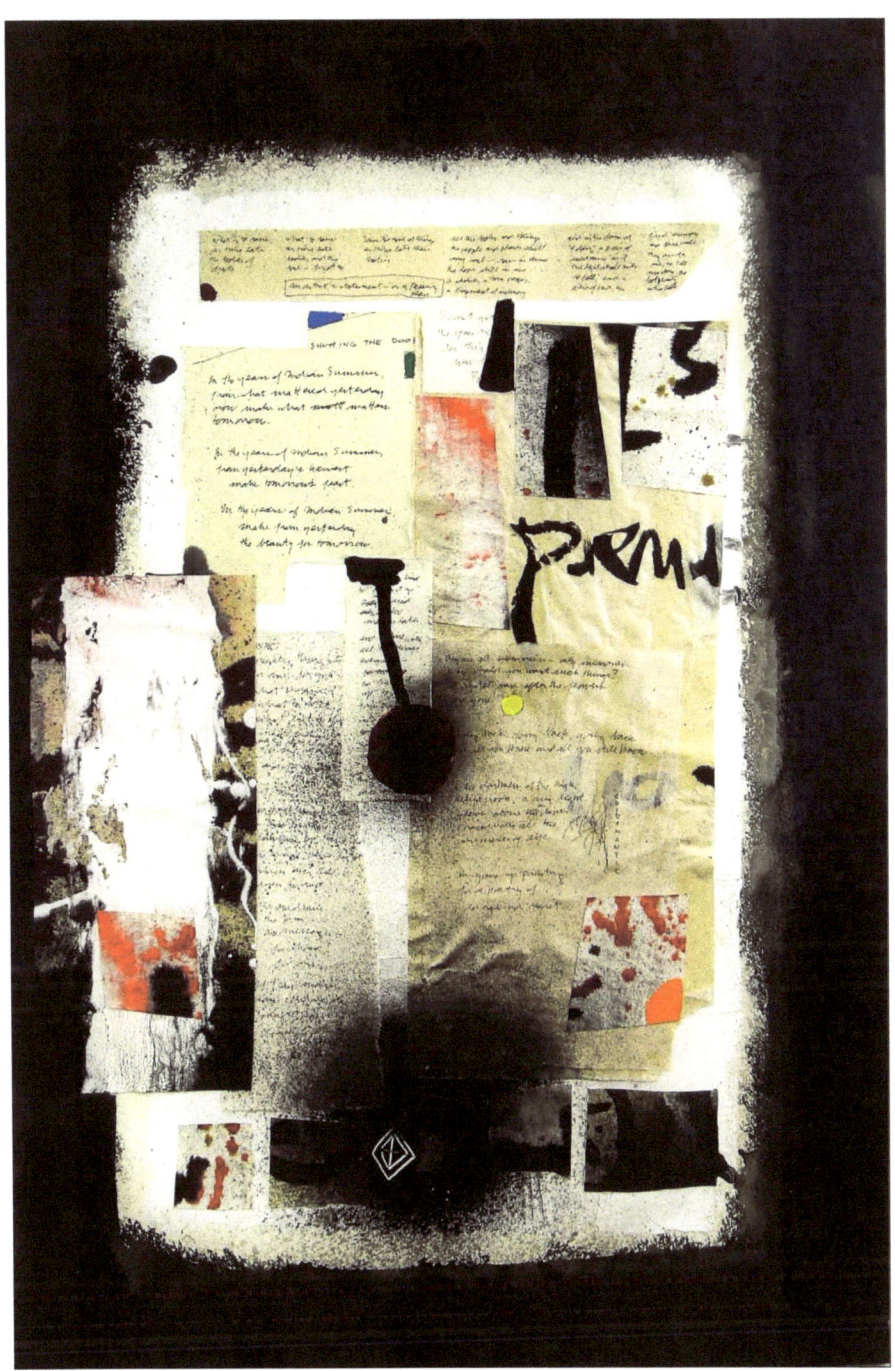

#1 May 2008. "The Big One." 44 x 30 inches.

May 23, 2008.
Oakland, late night..

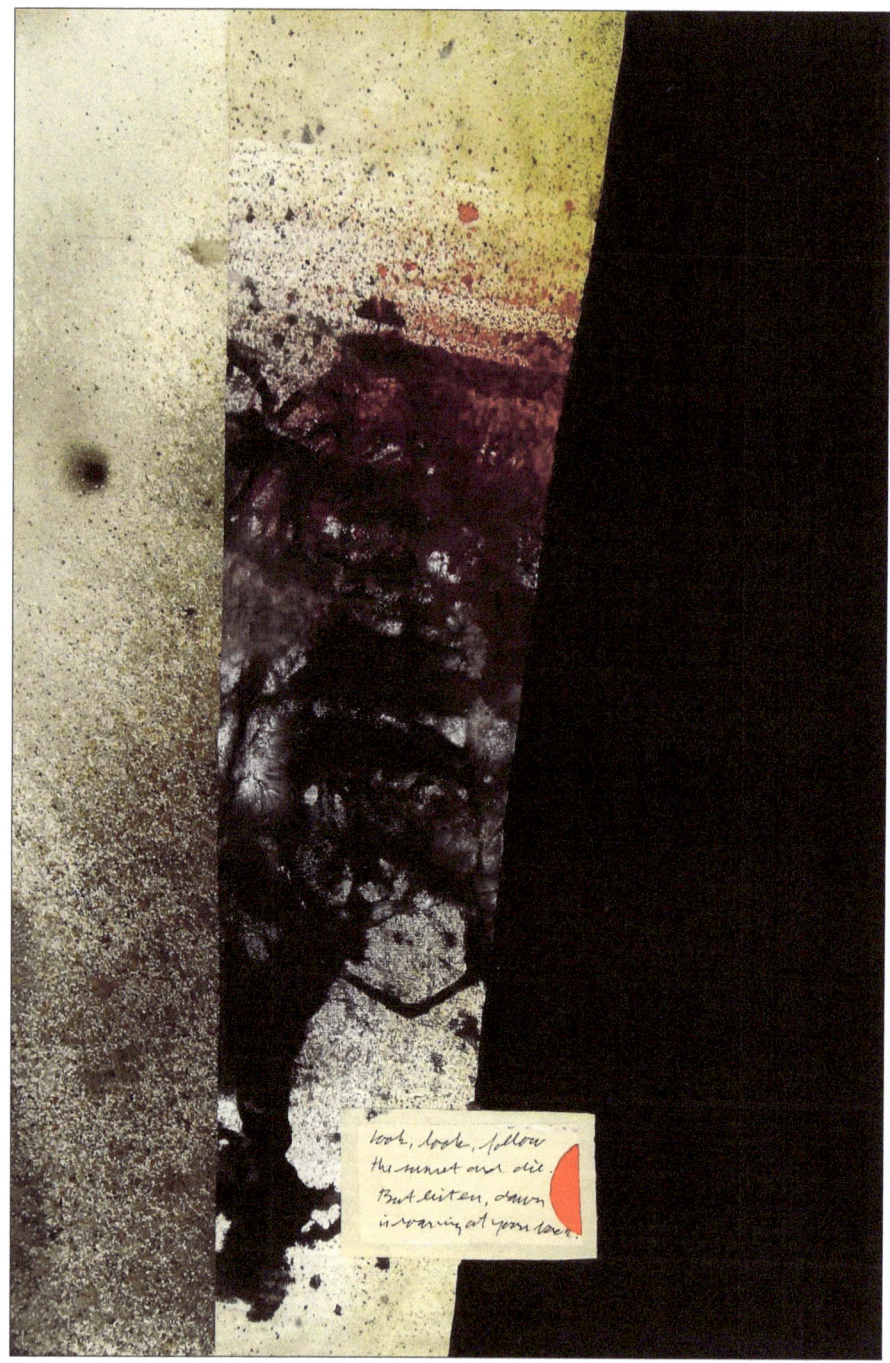

#3 May 2008. 22 x 15 inches.

On the painting—
"Look, look, follow the sunset and die. But listen, dawn is roaring at your back."

May 12, 2008
Oakland, night.
Begin what became *#3 May 2008*.
"We called, you did not answer."

May 16, 2008.
Oakland, very late night.
Thoughts for me, thoughts for you
what to save, what to lose
what lost to find, what broken to fix
and the rest forget
for me, for you and for us all.

If there is ever a problem for this time—
How to save the souvenirs of time lost so
"this light which once fell shall ever so fall even to final dust"
The medium, the form, the message?
To save for whom? For me.

If I care enough for mine
others one day
might in my example with mine
care then for theirs.

May 21, 2008.
Oakland, night.
Follow the sunset and die—but listen, the dawn is roaring behind you.
[I was watching the sun sink beyond Mt. Tamalpais and was following its path into the west when I felt at my back the east and sensed the sound of dawns to come.]

May 23, 2008.
Oakland, morning.
It is the end of the alphabet a…z, and there is nothing left. Some things are not circular. What do you do when you know you are failing?
SHIT!

Beat your head against the wall of the past that is all you have made before, and claw, scratch, beg against the night of the future. Dawn? Dawn? Dawn?

Afternoon.
Oh, still climbing, still climbing from the dust to the light.

Late night.
#3 May 2008.
"Look, look, follow the sunset and die. But listen, dawn is roaring at your back."

May 24, 2008.
Oakland, early morning.
Well, sonny, keep at it.

May 29, 2008
Montreal, afternoon.
No way to say
No way to know
No way to be
No way to show

Montreal, night.
Do you want me on the wall?
My dick hanging there, hungry, alive?
I think you don't.
Scared of the path, aren't you?
Yeah.
Well, get over it.

May 30, 2008.
Montreal, morning.
Needing a place for quick notes, found an old 3x5 card with notes already on it—

At the top:
"The old wind, the gray light, time eats"

Then in another pen a horizontal line of division and
Life hurts and art's no cure
Things die and painting's not immortality

It all breaks, the highest and lowest
all fall to dust

Then I found a stack of cards, some with dates…

April 17, late night..
I have no idea how to make it work, no idea.
I can't do it.

April 19, evening…
This is no way to live.
If you don't have a market in a market economy, why make the work?
The story of existence has no market. Yes, my story to myself matters to me, but why buy one? Only as a stamp collector's trophy—but, with no market, my works are not trophies.

It's the last end of the grand illusions with which I began. Like everything else since God died at the end of the 19th C., the illusions evaporated while the dust stains our fingers.

On the next card…
What you need to do now in art, Fred, is move on, finding new things, new ways…
Never cease until the brain stops

On the next card…
Thinking about the rich aesthetic orchestration of painting…do you need that? No.

On the next card…
Shit, Fred…
It's a long way down

Stop that one—
Never say die.

And then on a folded 8 ½ x 11 sheet…
Wherever you go
Whatever you want
Whatever you do
Wreck and ruin

*

And, finally, post-it notes from this morning…
They all go
High and low
All dust

You cannot do that, Fred—
clawing and reaching for the high, far, fading sky as the sun sinks …
And you who read this, you too cannot do it in the clouding, fading sunset.

*

Only a few scraps of the 2006 rice-papers left. Just as well. Now I want all the flesh, not the aesthetic stream, but the real meat and all its dying in time.

Die alive in flesh, not in the image.
Be in fact, not the image of it.

Lac Ouareau, midnight.
Learn to live and then learn to die… and all we know is by doing.

In our older ages, we need less stuff.

There is a very clear lesson there, and it is very small and very absolute.

May 31, 2008.
Lac Ouareau, morning.
So little to say and less to show to mean so much

So little to say and show
for so much to know.

May 31, 2008.
Lac Ouareau, late night.

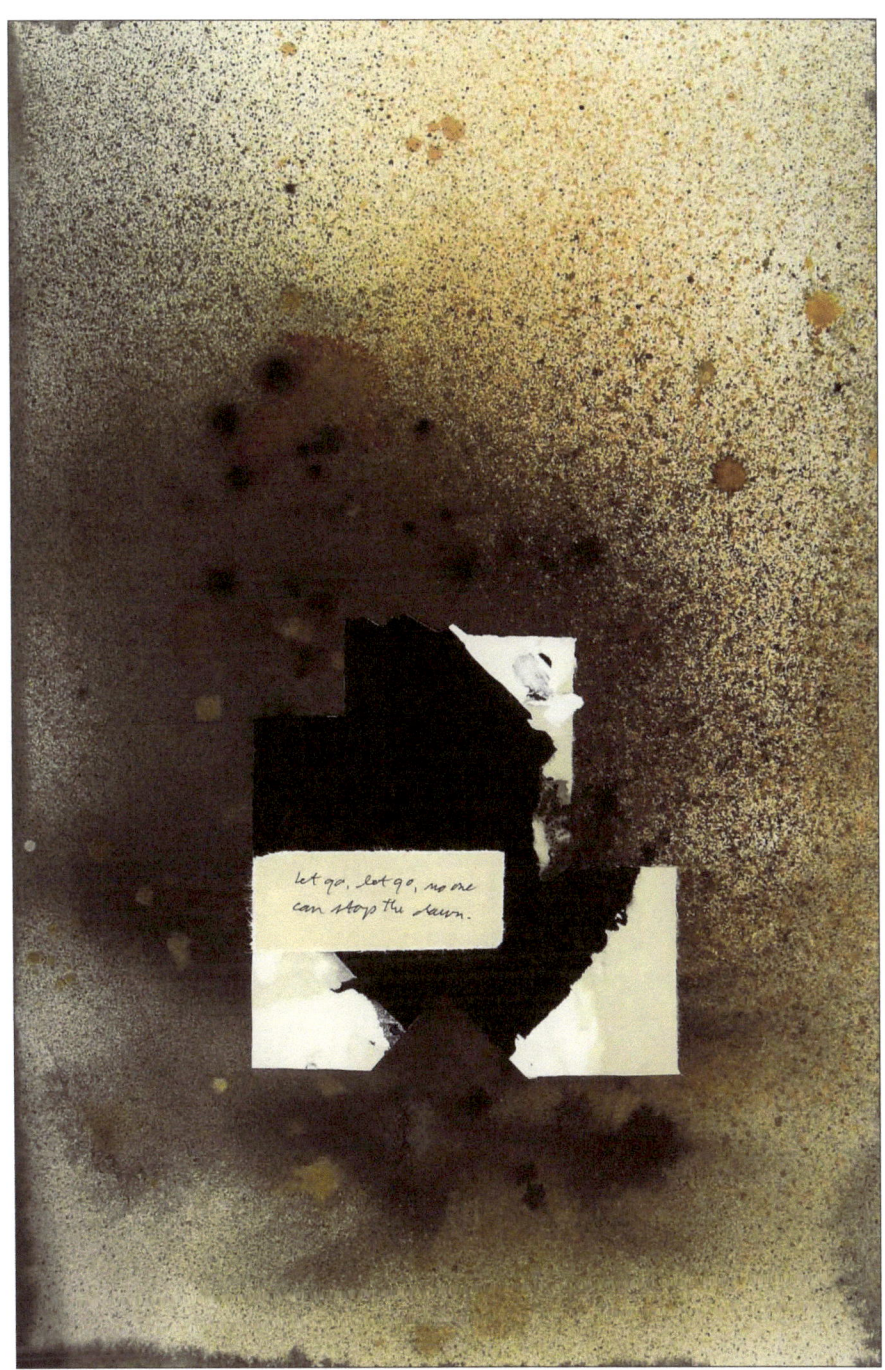

#4 May 2008. 22 x 15 inches.

On the painting—
"Let go, let go, no one can stop the dawn."

June 11, 2008.
Lac Ouareau, morning and afternoon.

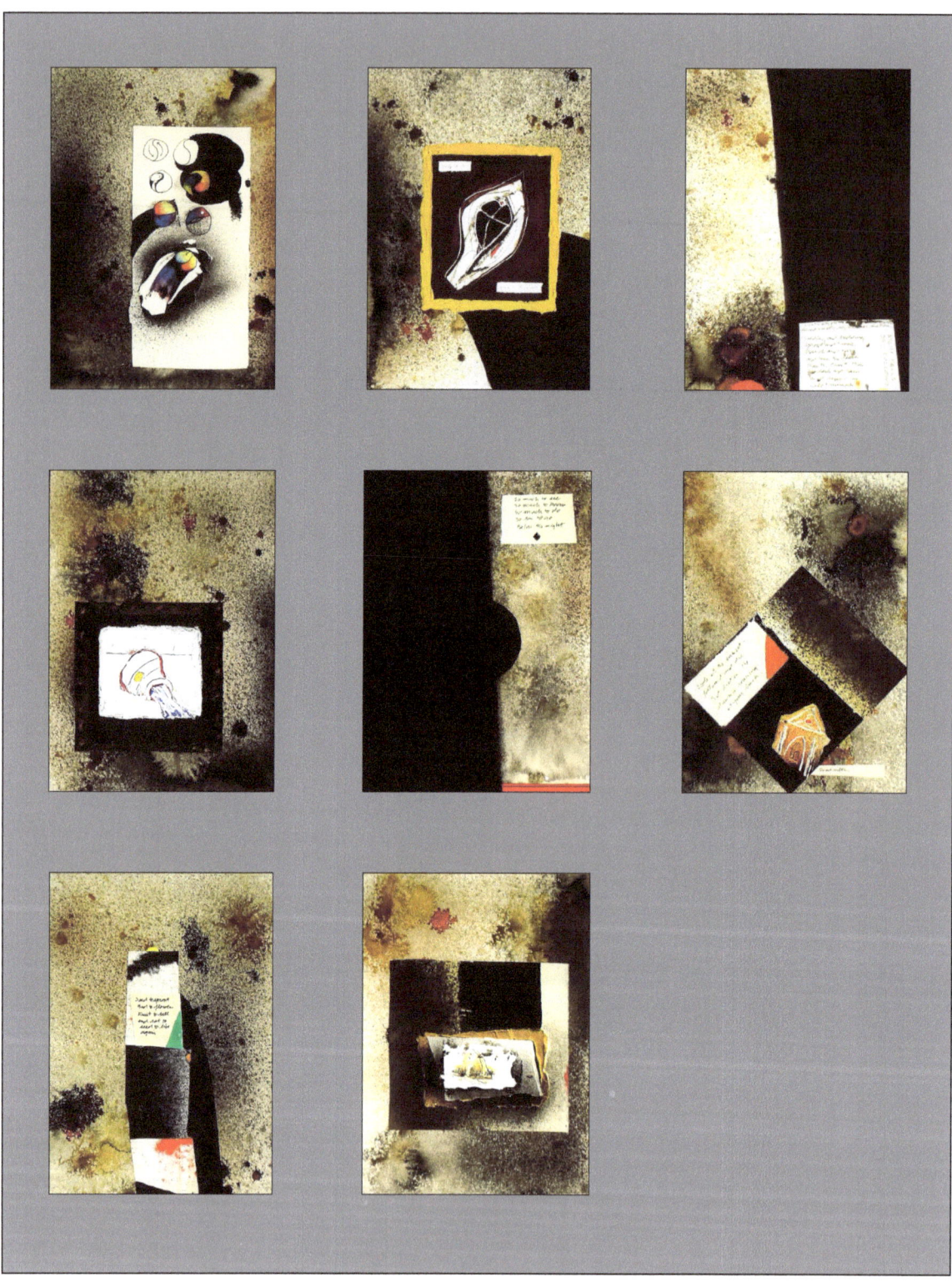

Top row, left to right—*#s 8, 9, 10 June 2008.*
Second row, left to right—*#s 11, 12, 13 June 2008.*
Bottom row, left to right—*#s 14, 15 June 2008.*
All 22 x 15 inches.

June 11, 2008.
Lac Ouareau, morning.
#8 June 2008.
I, Gemini.
A very early morning note:
Why should I not show this thing source of all my glory and shame, pleasure and pain, building and ruin, beauty and ugliness, light and shadow, the endless turning source of all my drive of life?

It is sex that drives us out of childhood into time, from a timeless Paradise into the living and dying of the generations.

In 1956 and at the Oakland Museum and matting the Esther Fenner Fuller collection, I fell without noticing out of the Battle of the Titans. I had dozens of small rectangles cut from mat board to make the windows for the prints and drawings and had nothing to paint on and painted on those. After the 6 Gallery show with fifty or a hundred of those little things (we had lots of museum installation generated bits of plywood in addition to the mat board pieces), somehow for so many years and now again, those small things have become my format and size.

Afternoon
#9 June 2008
On the painting—
"Odd bud, only blood."
[A revisit of the late 1950's eucalyptus pod.]

Night.
#10 June 2008.
On the painting—
"Night falls, day follows
The rest is only pretty, only message matters. Seeding and budding, sprout and trunk, branch and twig and then the flower then the fruit. Then the dark and rain and snow—we will triumph."

June 12, 2008.
Lac Ouareau, night.
#11 June 2008.
A revisit of The Urn Overturned.

Thinking about these images, especially the urn which was on my 1967 Royal Marks announcement that I no longer have a copy of. What did it say, what did it look like?

And then remembering the manuscript dealer who called to say he had bought Jim Elliot's library and archive, that it had something of mine in it from Dilexi and how much did I think it was worth. (How should I know?) Now, maybe twenty years later, I wonder if he had a copy of the Royal Marks announcement, and who may have bought it, and for what reason. It will never be an "art historical object," because I have not made nor will a mark in the history of styles that since Vasari is art history in the West. Any mark I make is only the mark of the times of a man's life, and there's certainly no art history to be made in telling my story because everyone has each their own story that's more important to them than mine. My contribution to society is simply to say, "Use my example to believe in yours"

#12 June 2008.
On the painting—
"So much to see, so much to know, so much to do, so far to go before the night."
[With evening star]

June 13, 2008.
Lac Ouareau, last night and this morning.
Keep the dawn coming, the signs and symbols, the age old game of cards of the signs and symbols of all and ever.

Remembering *The Roman Tomb* from the mid 1960's when the collage period was dying away, begin *#13 June 2008* as "The Roman Tomb"…

#13 June 2008
On the painting—
"Look at the sunset—follow it and die… But listen: the dawn is roaring at your back. Remember."

#14 June 2008.
On the painting—
"Seed to sprout, bud to flower, fruit to fall and rot to seed and live again"

#15 June 2008.
Remembering the 18x18 inch "Little Gray Home in the West."

June 19 2008.
Lac Ouareau, afternoon

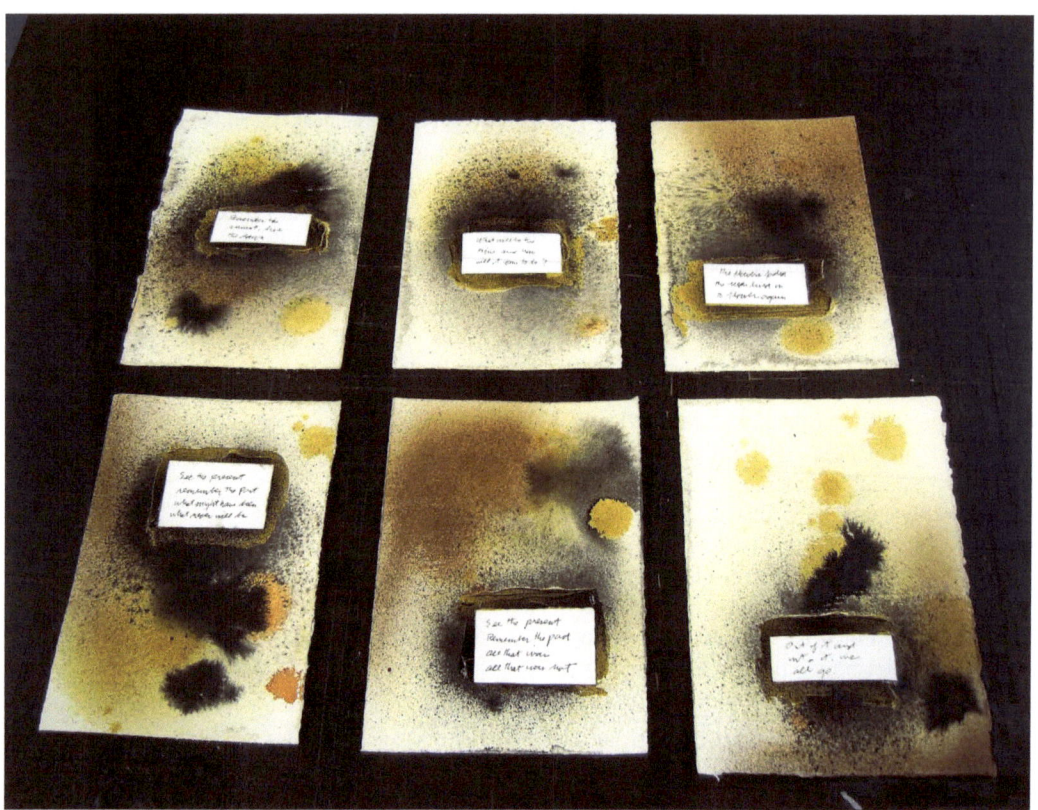

Left to right, top to bottom #s *20 a, b, c, d, e, f June 2008*
All 22 x 15 inches.

On the paintings—
20a. "Remember the sunset, live the dawn"
20b. "What will be the time, and how will it come to be?"
20c. "The flowers faded, the seeds lived on to flower again"
20d. "See the present, remember the past, what might have been, what never will be"
20e. "See the present, remember the past, all that was, all that was not."
20f. "Out of it and into it we all go."

June 22, 2008.
Lac Ouareau, night

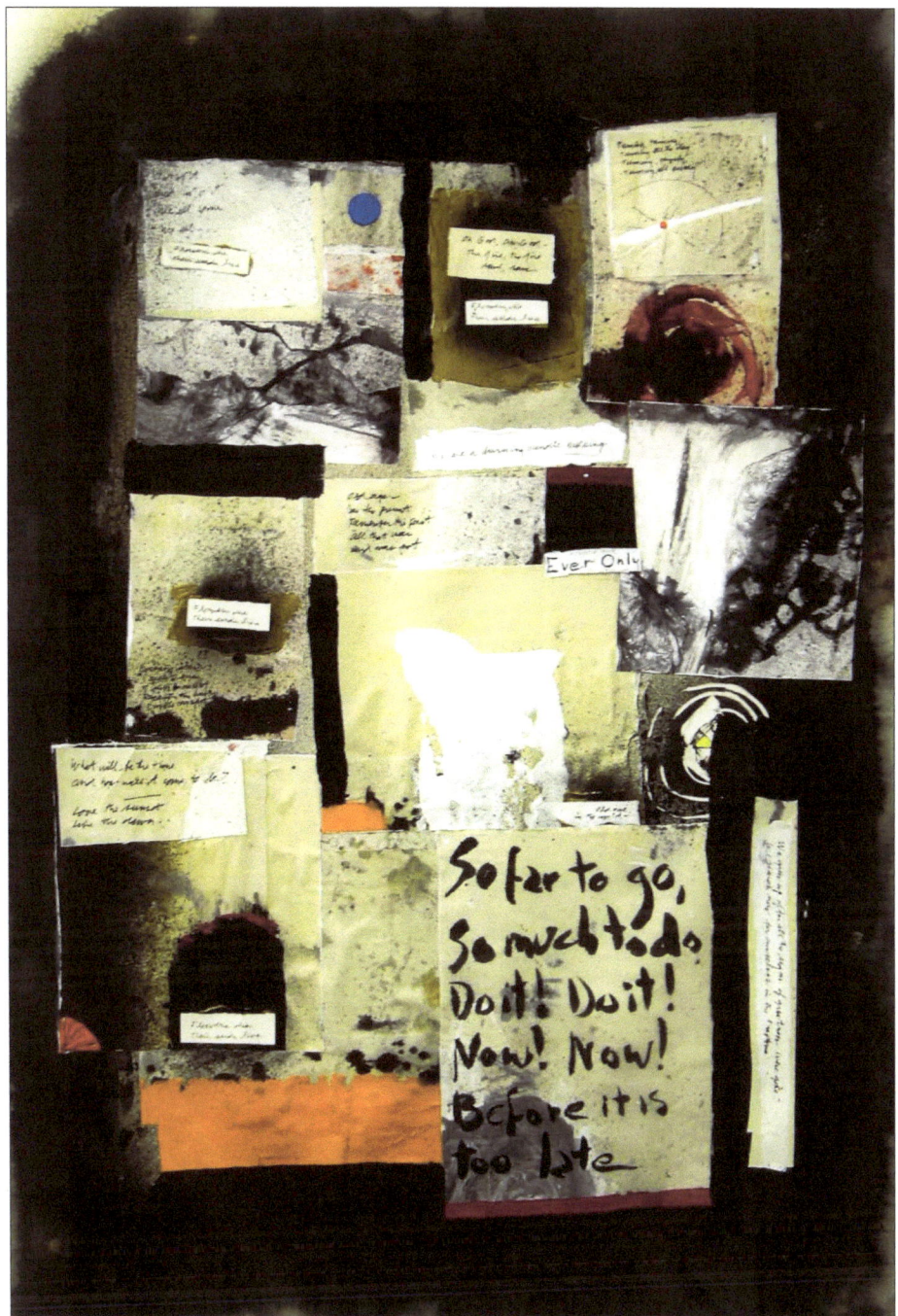

#25 June 2008. 44x30 inches.

On the painting—
"So far to go, so much to do
Do it! Do it!
Now! Now!
Before it is too late."

June 29, 2008.
Oakland, late afternoon.
Tell me how to get there,
Tell me how to get there—
But, first, tell me where to go…

Sunset.
Learn to paint, you stupid shit.
'Tis the salve for every sorrow, cures all your troubles.

Night.
You will notice among the disappointing factors of your life as the years pass, is that you will have accumulated associations for colors, and that as you use those colors you will hear the colors tell your story—a disappointing factor because those are your color associations, not those of someone (anyone) else. You hear your story in your colors, but they see only their colors and hear only their stories.

June 30, 2008.
Oakland, morning.
1. Light may come
2. Means never

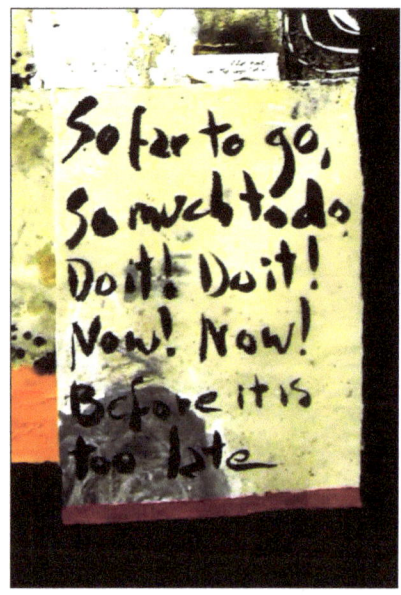

July-December, 2008.

Not so much talk
—there was so much on so many never transcribed scraps of paper—
stick now with just the pictures and their few notes.

But, from July, these few notes that never got pictures…

July 11, 2008.
Montreal, morning.
We have so far to go
So much to know
Before it's over.

Afternoon.
Life and time and the ending in dust
so fertile for tomorrow.

Night.
Flowers bloom and die
Old days, old ways pass
Memory stays.

July 13-23, 2008.
Russia trip
July 14-18, St. Petersberg
July 19-22, Moscow.

July 25, 2008.
Lac Ouareau, afternoon.
We are only sand between the fingers of those who come after.
Maybe there's only ashes and dust, but the cum shines through.

Oh, stars in the sky; oh, trash in the street,
The desert sand, the dust in the corners
Are all of us at the end
Never forget the evening star calling.

And, copied from June 29—
Tell me how to get there;
But, first, tell me where to go.

July 5, 2008.
Lac Ouareau, morning and afternoon.

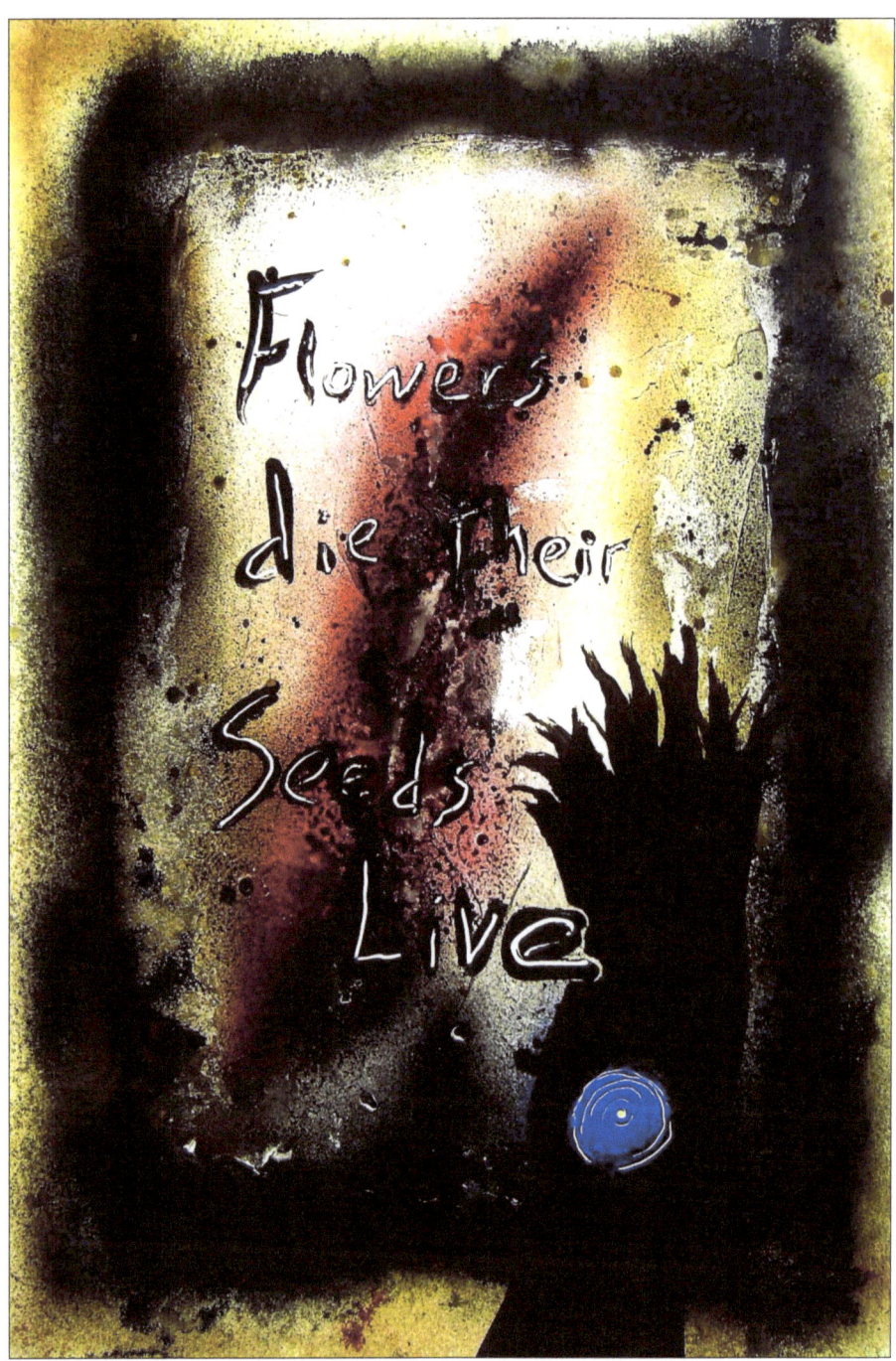

#2 July 2008. 44 x 30 inches.

On the painting—
"Flowers die, their seeds live."
[So far to go,
So much to know before I die.
And spirit tells the story.]

July 6, 2008.
Lac Ouareau, late night.

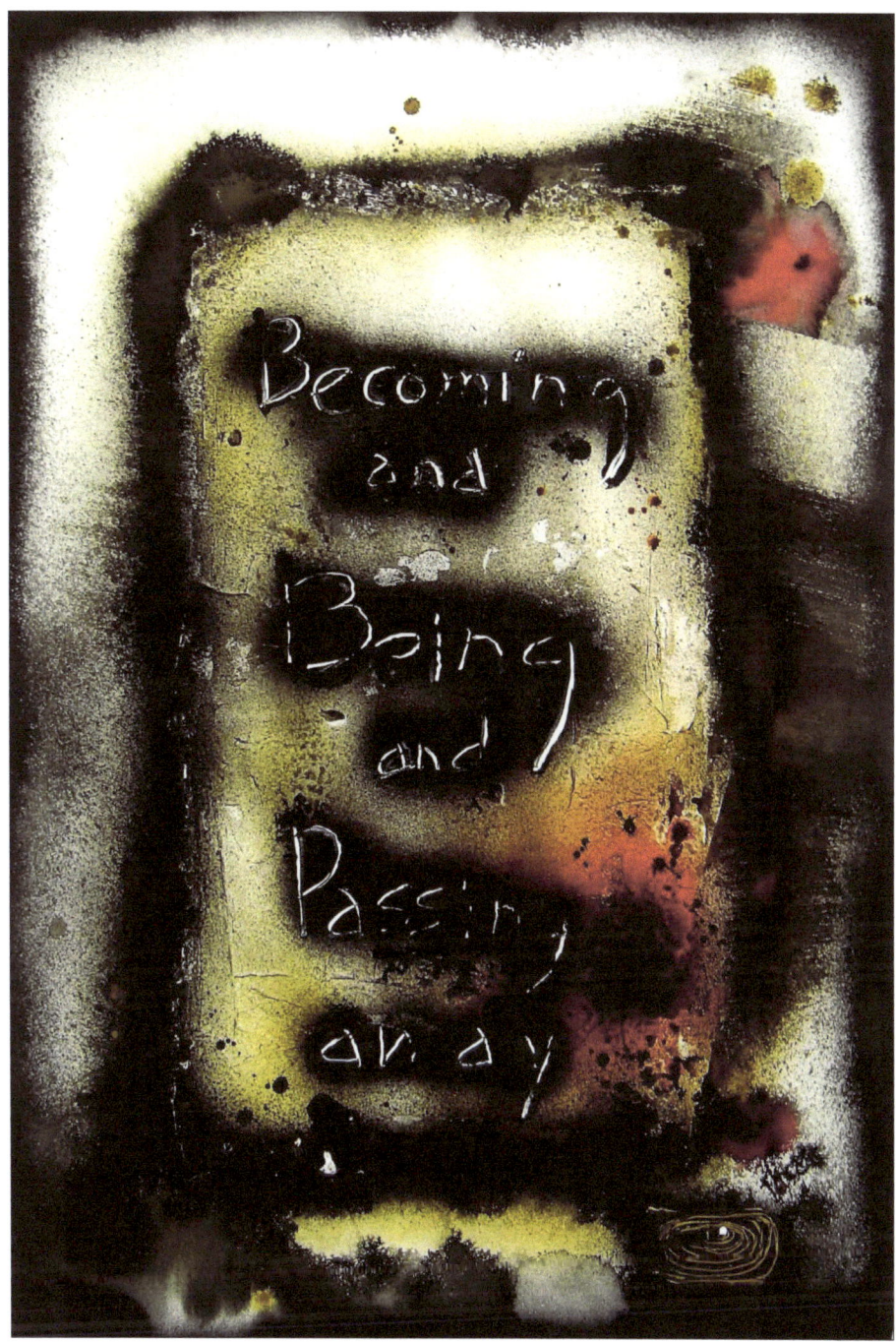

#3 July 2008. 44 x 30 inches.

On the painting—
"Becoming and Being and Passing away"

July 7, 2008.
Lac Ouareau, early morning, late at night..

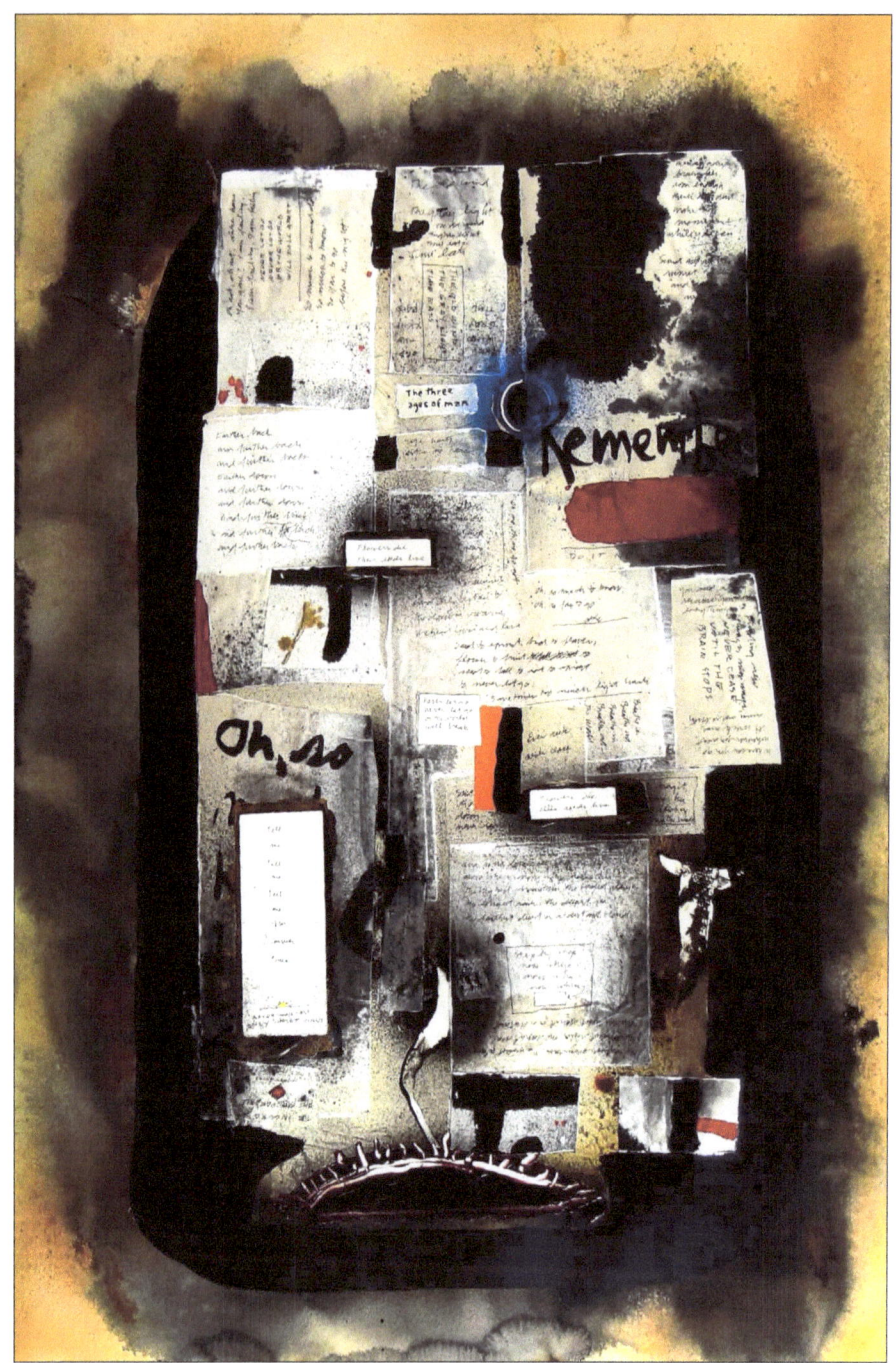

#4 July 2008. 44 x 30 inches.

On the painting—
"Never let go, never let go or the world will fall apart.
The world fell apart when it broke you;
when you broke, the world fell apart."

Always remember, never forget, the Evening Star calling.
[But I made *#4 July* instead.]

July 25, 2008.
Lac Ouareau, afternoon and late night.

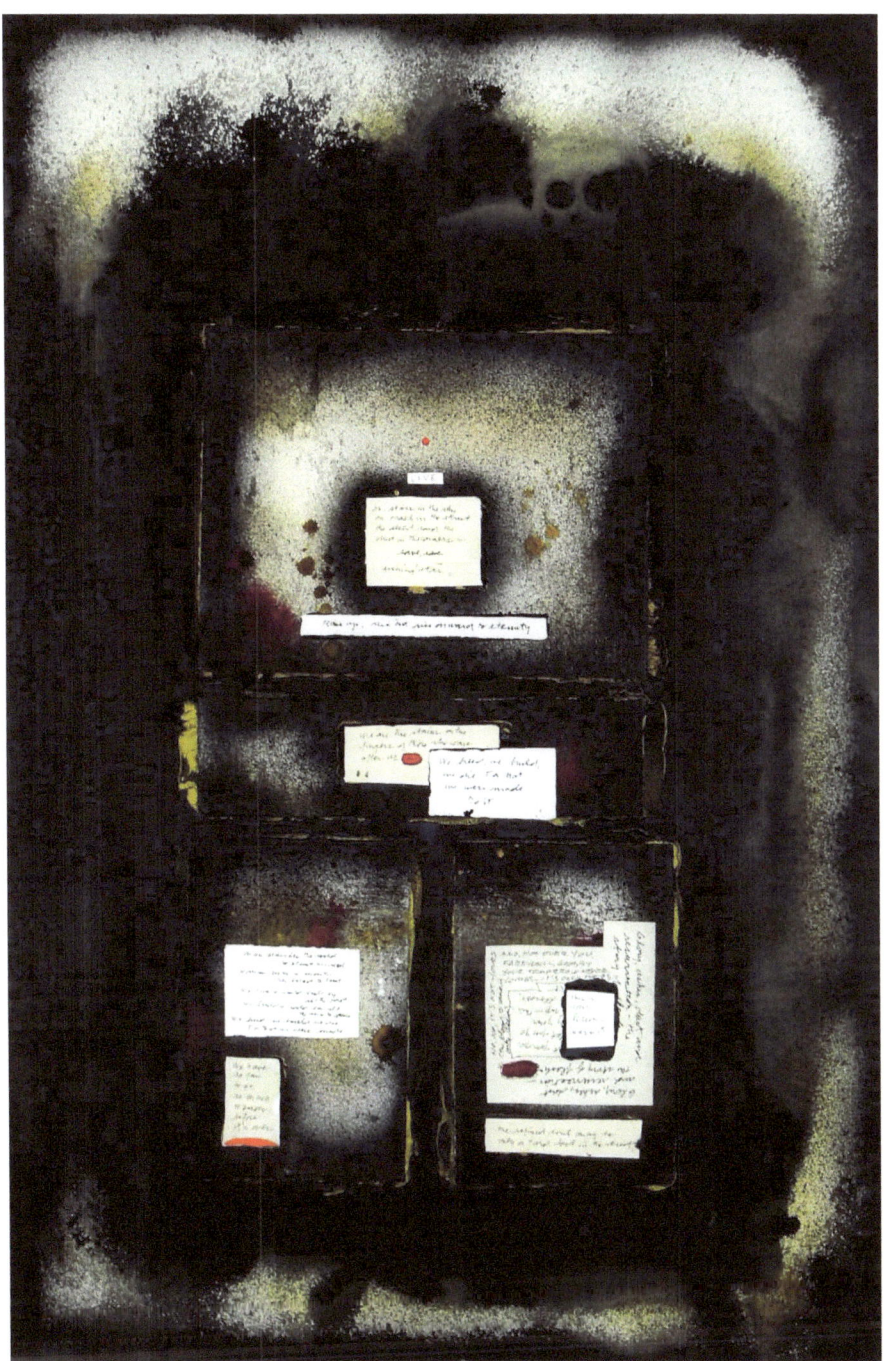

#7 July 2008. 44 x 30 inches.
On the painting—
"LIVE. We are only sand between the fingers of those who come after."
"Maybe there's only ashes and dust, but the cum shines through."
"Oh stars in the sky, oh trash in the street, the desert sand, dust in the corners—
save, save, evening star."
"Rise up, rise out, rise onward to eternity."
"We are the stains on the fingers of those who come after us."
"We breed, we build, we die. For that we were made. Do it."

July 27, 2008.
Lac Ouareau, night.

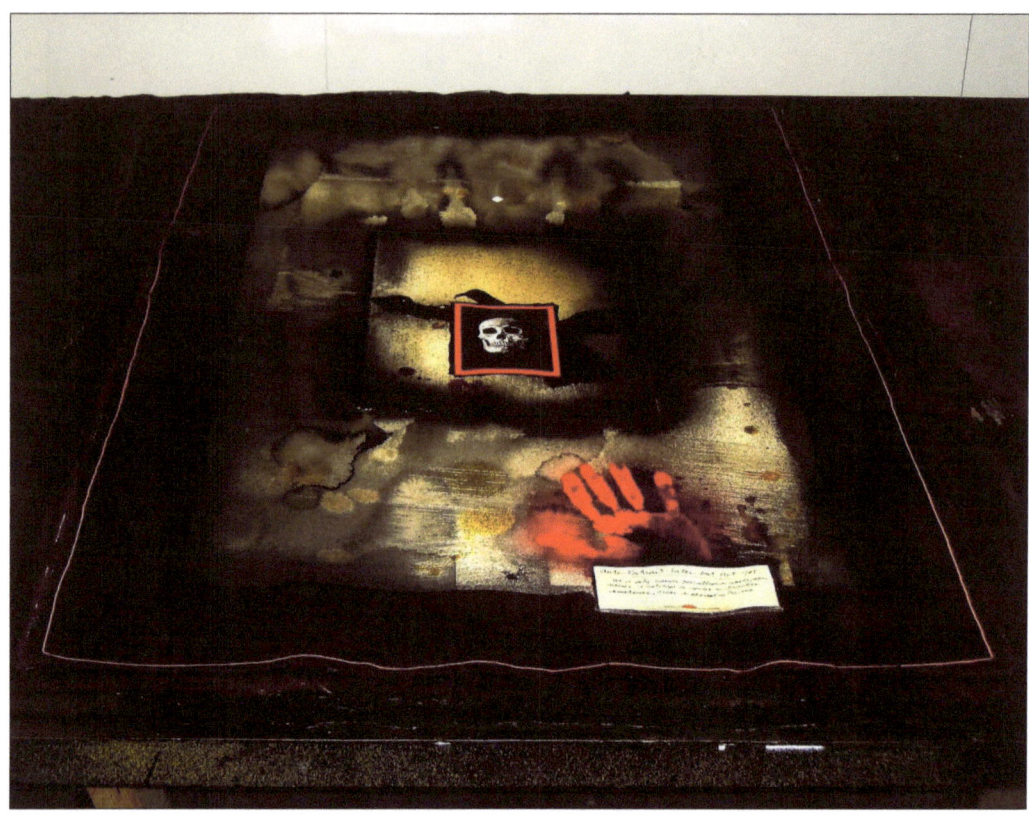

#9 July 2008, still wet on the studio table. 44 x 30 inches.

Title: *Self Portrait But Not Yet*

On the painting—
"We is only names penciled on wastepaper,
scratched on rocks in forgotten cemeteries,
ashes scattered in the sea."

August 14, 15, 2008
Lac Ouareau, night.

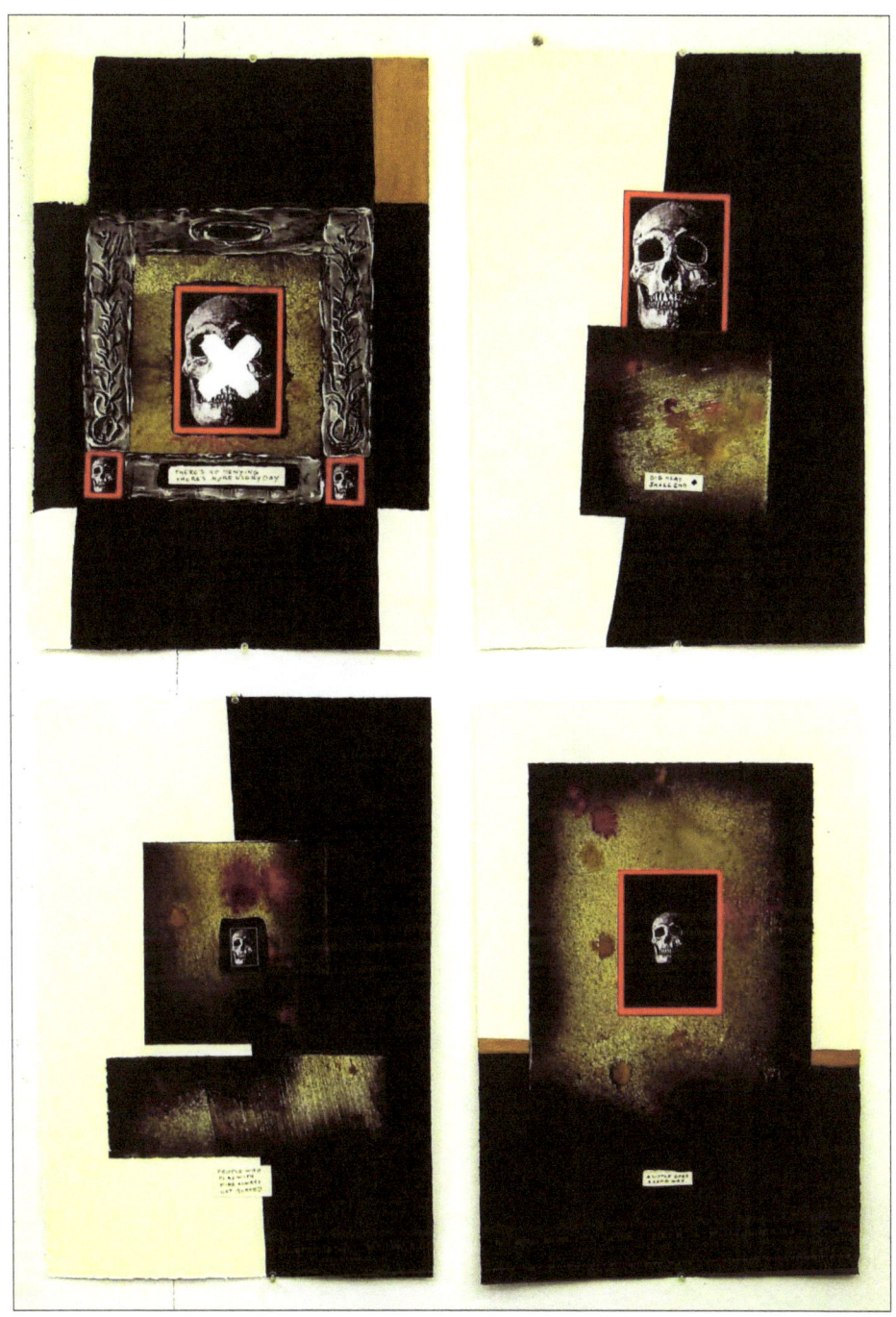

Left to right, top to bottom, #s *2a, b, c, d August 2008.* Each 22 x 15 inches

On the paintings—
2a. "There's no denying there's more every day."
2b. "Big head, small end."
2c. "People who play with fire always get burned."
2d. "A little goes a long way."

A footnote: Used to be, had to be, a dick in it. Now it's a death's head I can't do without.

August 27, 2008
Oakland, very late night.

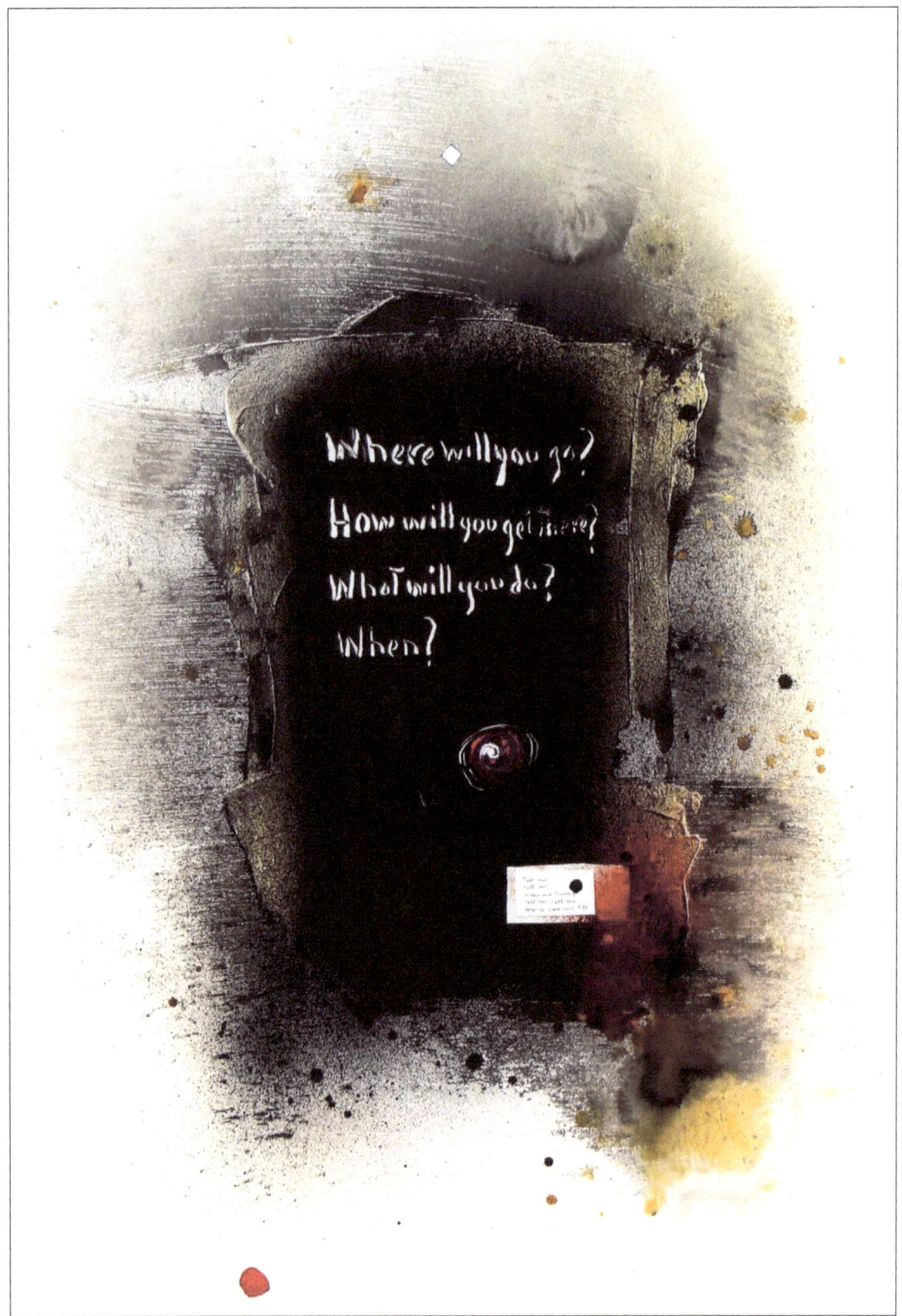

#4 August 2008. 44 x 30 inches.

(Note: the star of endless aspiration near the top
and the thumbprint of undying physical blood in the style of a Chinese seal near the bottom
were added September 6 as a result of writing a piece for submission to a Chinese magazine.)

On the painting—
"Where will you go? How will you get there? What will you do? When?
Tell me, tell me, where am I going, tell me, tell me how to save my life."

September 29, 2008.
Oakland, 1:01 am.
A note from May 18, 2008:
Think: Where will the work reside?
Never mind the basement; of course it will be in my basement, your basement, the museums' basements or attics or the dump. But, aside from those final resting places, where did you in your mind make the work to be? And that leads to for whom did you make the work?

Well, we all know we work for the highest, and the art world highest is the museum and the art magazine. The editor of a major art magazine once told me when I asked if he considered the impact of his magazine covers on the art of the future, "An art magazine is journalism, and we put on the front the jazziest photo we received last month." (Hardly the place to find a solitary, still, small voice). The museum, a museum director told me once, is a place "To collect the finest and to educate the public to its value." And as for what is the finest, that's a professional judgment formed by conversations within the profession... hardly the place to hear a solitary, still, small voice.

So, what size should your work be? Big enough to be seen by the masses of people in museums for education, jazzy enough for journalism to place on covers where museum professionals will see it?

But what of the solitary, still, small voice—the sound we each hear when the noise of the world stops—where should that work reside?

What to do with and how to make that work not addressed to the professional world but rather to the solitaries in the midst of their thoughts. Not loud like a magazine cover but quiet like a dark, silent despair, not large like a space for educating a museum public, but small like the inner place of forever grief for a lost loved one—or for you, your self.

#s 1 and 2 September 2008 were so slow to develop, scattered across so many days and nights, that it is difficult to tell from the September notes when they were completed. So both of them are together on the next two pages, here at the end of the month.

There were only two. Why make more when the two have already said it—the path of life.

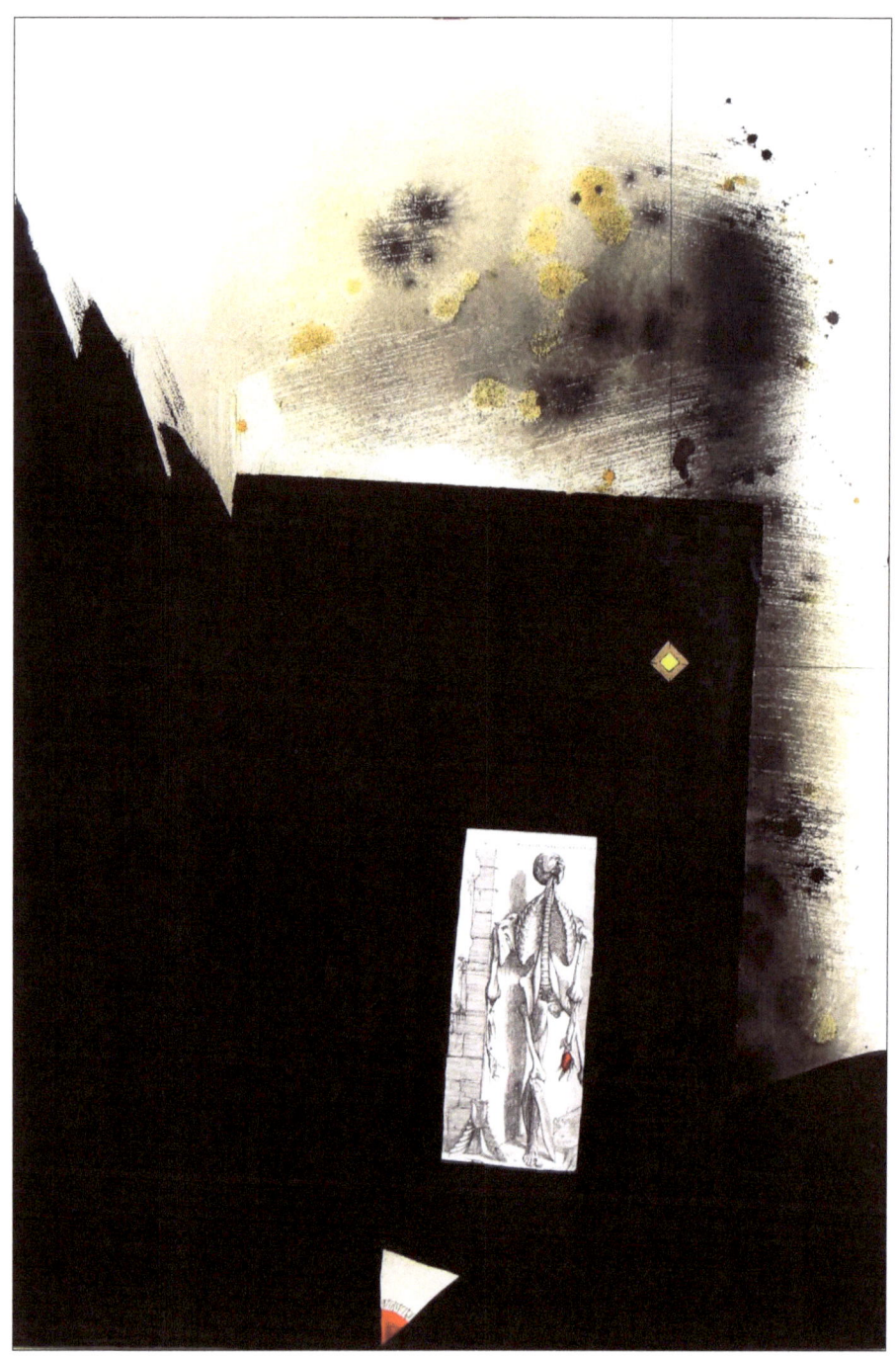

#1 September 2008. 44 x 30 inches.

#1 September 2008 is the path from dawn through the flesh to the evening star.

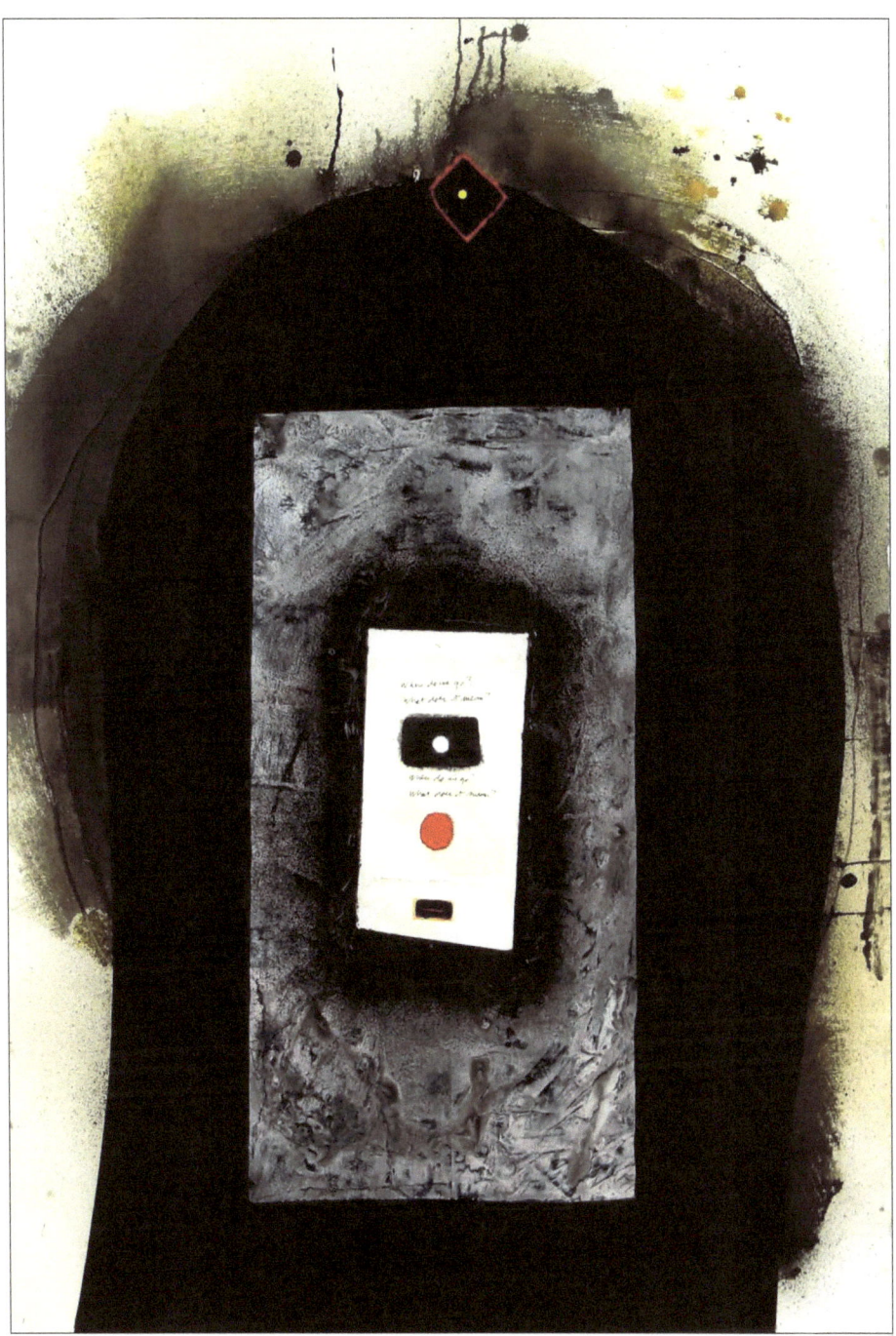

#2 September 2008, 44 x 30 inches.

On the painting—
"Where do we go? What does it mean?"
[Then a white spot in a black area. That's the cum that's the star.]
"Where do we go? What does it mean?"
[Then a red disk made by smearing with my thumb for Mars, the male life force.]
[Then a black bar for the coffin with a thin red slit in it for irrepressible life breaking through… the image as a memory of my 1969 painting of me in my coffin with the Tree of Life growing up out of my cock.]

October 5, 2008.
Oakland, noon.
Looking again at *#2 September*...
Where do we go?
What does it mean?
From the cum spot
to the life spot
to the grave were ineradicable light breaks through.

What more is there to make?
Remembering how it had been once, that "There is immortality but it is not you"—yes, life is immortal, but everything—even the rocks—always dies to come again as something else... at the last as entropic dust.

Very late night.
Put *#1 September* up beside *#2*. They don't like to be together. And of *#1*, it is "The way of all flesh."

More very late night.
I remembered "And so when evening comes," an 18x18 inch collage from the mid 1960's, a memento of a late afternoon with Jean in the gardens of the old San Juan Bautista Mission near Hollister that had been restored by William Randolph Hearst.

October 6, 2008.
Oakland, late afternoon.
While walking to the bank I heard
"All that is found is one day lost
All that is treasured is one day forgotten"

October 7, 2008.
Oakland, early morning.
Everything you find, you finally lose;
Everything you know, you finally don't;
Everything you treasure, you finally forget.

And as for standing up, at the end you will surely fall down.

A note about the above
written on October 24, evening.
The above is not pessimism, is only telling the truth—and anyway after you are dead there's no "you" and so you have lost nothing

October 10, 2008.
Oakland, night.
From a note sometime mid October...
(Has a note at the top: "Drunk at Sunset")
The lie of life, the lie of life

And when it comes to you that you've lived it, what then? Mine was based on readings/seeings in late 19th-early 20th C. art and literature, that the deepest individual personal is the truest across all individual persons—

And so my private transformation shown in "abstract" images (ambiguously open to anyone's projections) were/would be/are now only my personal clothes of the archetypal body of man in time. (But I read them as the *avant-garde* of those decades 1948-1988... until, well, even the last year or two.)

But, now, looking back, sure it was that Mama said, "Everybody's out of step but Freddie..." But that was more than half a century ago and now both Mama and Daddy (who supported me no matter what) are dead thirty-thirty five years.

In the meantime, the work in the world I did to support me and my family (and my "existential" beliefs) is over. Move on into the twilight say the people now four generations later; maybe a few people a couple centuries on will find that your images of life give them lives—a new "lie of life" like Theosophy and the icons were for Kandinsky—if the paper in the archive of the worthless then still remains.

—SO THAT IS WHERE IT (THESE THOUGHTS) COMES OUT—

Watch it down the centuries, don't think too much—and, find a new medium that makes a new form for your own time.

October 11, 2008.
Oakland, late afternoon.
All those people gone, not a trace of their passage remains in the time of the present except in the memories of the minds of the living and until their minds fail... even then some people long dead certainly will have left traces in the bodies of the living persons who knew them: some neural paths set once or several times will remain in the still living until the deaths of their bodies.

*

Fading, closing, the autumn of the year
But there remain until death
The deep cut marks of pain and pleasure
From the birth pang until the end.

October 12, 2008.
Oakland, noon.
I have lost my way.

They are book pages, they are manuscripts, they are not paintings on a wall.

Oakland, night.
Some notes transcribed from 3 x 5 cards…
Dated September 29, Oakland, morning—
So far to go,
So little we know.

Dated October 10, Oakland, night—
How many pieces make a whole,
How many losses makes a ruin?

Undated—
Looking at Art in America… It is what it is (the art world), and I'm telling you, it is not mine.

How, how, how will you know?
How, how, how will you go?

Those are the places where the things are to paint—to last forever until I'm dead.

Ocober 16-23, the October China Trip
October 16, San Francisco to Beijing.
October 17-19, The 90th Anniversary Celebration of the Central Academy of Fine Arts, Beijing.
October 20, to Shenyang and the Luxun Academy of Fine Arts
October 21-22, The 70th Anniversary Celebration of the Luxun Academy and the grand opening of the Dalian Campus.
October 23, Dalian to Beijing to San Francisco

October 22, 2008.
On the road Shenyang to Dalian, late morning.
Rubble in a valley, the remains of a life.
Mounds and hills come and go, thoughts pass.

Do not make paintings passed unseen on a wall.
Make a manuscript folded in a book
One day someone opens the book
A light shines out.

Quiet, quiet, walk on alone.

October 24, 2008.
Oakland, night.
It is just there...
A painting is a statement: a Dutch still life of "See how fancy my food is"; or "See your beauty wilt like these flowers"; or a French or British portrait of "See how grand I am"; or a French 18th century landscape of ruin as "How the great have fallen..."

Every painting is a statement, even if only the statement of color and shape and line.

So, too, these are statements. The only difference is, the words are upfront, not at the back of your head waiting for you to think of something else.

October 26, 2008
Oakland, late night.
Tearing off the attaching strips on the back of a 1995 painting from the Fred Spratt Gallery show…
"Be careful. He seriously damaged his best work." No one knows what is/was your best work. Nor do you. "Best" is what the later market says.

October 29, 2008
Oakland, very late night.
To whom do you speak
and how do you say
this very long time
passing…

October 26, 2008.
Oakland, late night

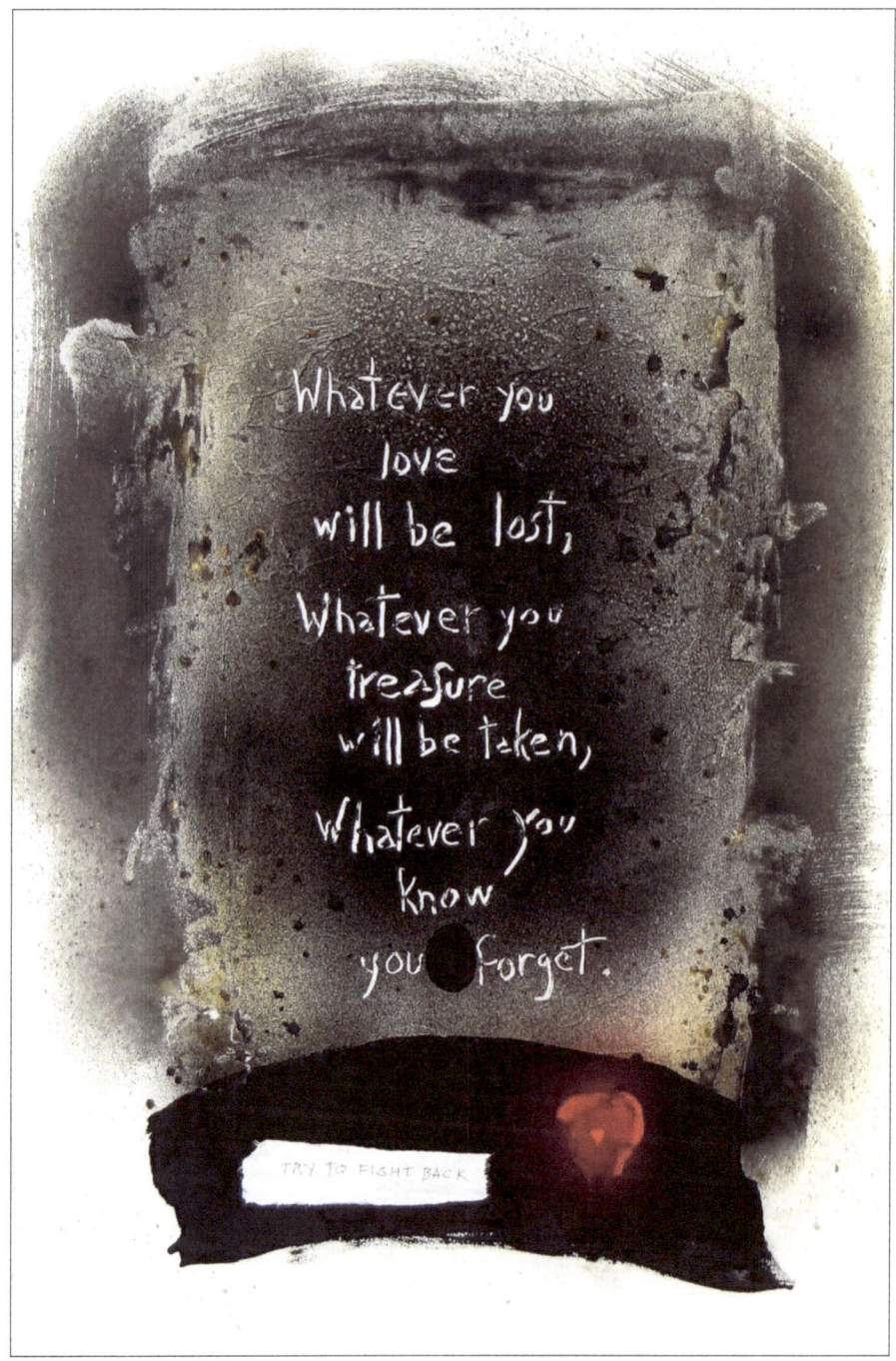

#1 October 2008. 44 x 30 inches.

What it says on the painting—
"Whatever you love will be lost
Whatever you treasure will be taken
Whatever you know you forget."

"TRY TO FIGHT BACK"

October 29, 2008
Oakland, very late night.

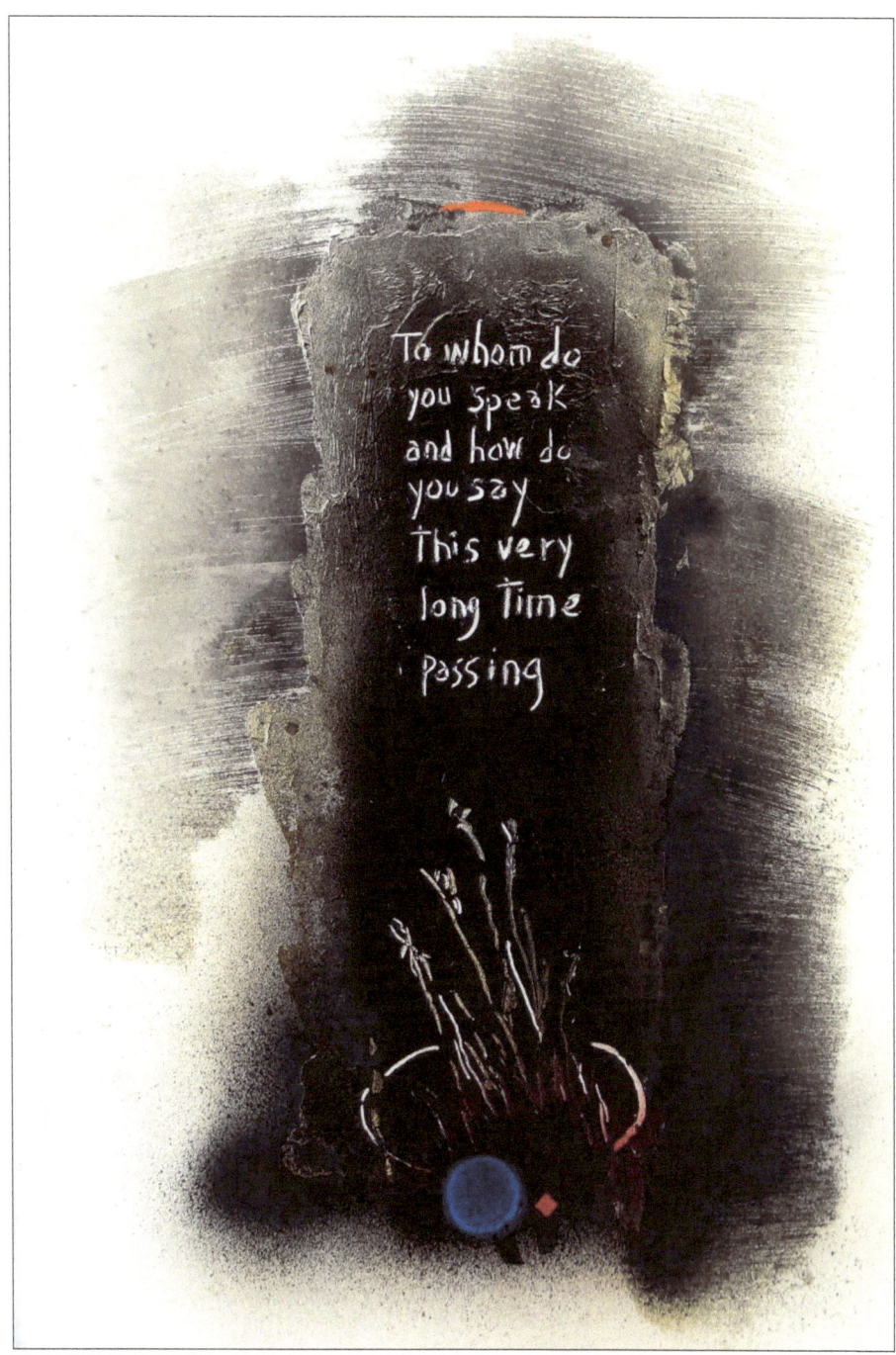

#2 October 2008. 44 x 30 inches.

What it says on the painting—
"To whom do you speak and how do you say
this very long time passing…"

What it shows in the painting—
The grave stone topped with eternity sun, the old grass gone to seed in the ring of the fire of life,
the red star diamond of the life force, and the bottomless pool of the waters of life.

Undated in November.
Oakland, late night.

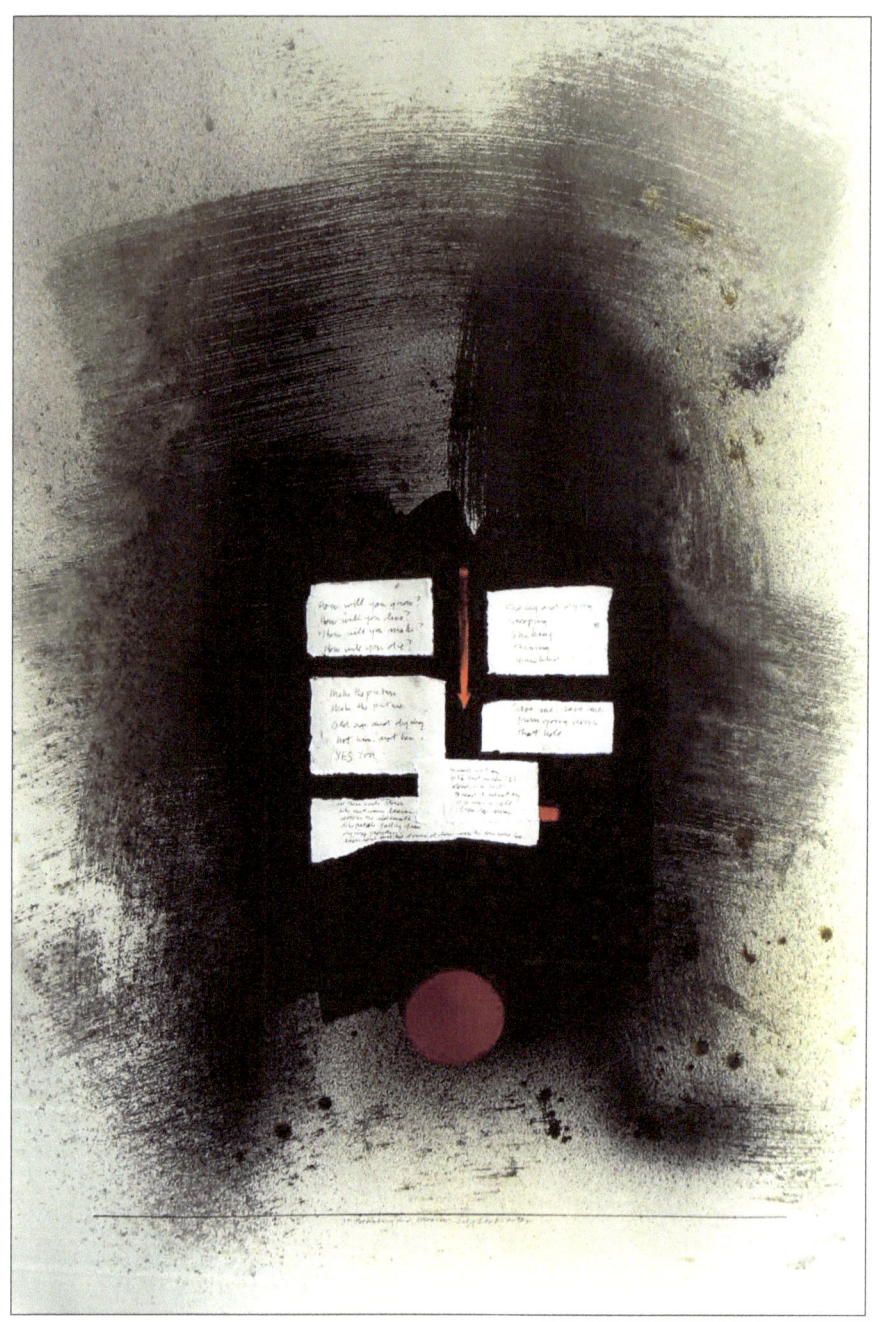

#1 November 2008. 44 x 30 inches.

What it says on the painting—
"How will you grow? How will you live? How will you make? How will you die?"
"Fading and dying, stooping, shaking, thinning, wrinkled"
"Make the picture, make the picture, old age and dying, not him, not her YES you."
"Save me, save me from going down that hole."
"To read writing in the first person [I] aloud is to be it.
To read it silently is to hear a call from far away."
"All these souls blown like autumn leaves down the sidewalk, like petals falling from dying flowers, each soul that formed of love, now the love gone too."

November 1, 2008
Oakland, very late night.
Looking at *#2 October*...
No star. Only the Eternity Sun at the top, the Pool of the Waters of Life at the bottom, and in between them the old grass surrounded by its ring of fire. So, I can still paint.

November 2, 2008.
Oakland, very late night.
More work on *#2 October*...
I enlarged the pool, then wondered if I should put the tiny red seed of life in it...
Well, no. Put the red diamond into the dark earth of the old grass instead.

November 3, 2008.
Oakland, morning.
Looking at *#2 October* this morning:
Tell me, tell me the way,
Show me, show me how to go...

November 6, 2008.
Oakland, morning.
Nowhere, nothing, no how.

November 18, 2008.
Oakland, late night.
The deep river of red with the eternal cum line squirming through it.

November 19, 2008
No place no time indicated.
Not "Marks of weakness, marks of woe,"[1] but everywhere I see marks of age, decay, decrepitude and death. And for my art, the same. This is not good. We have got to change. This is not good.

November 21, 2008.
Oakland, late night.
Death knell, death knell,
Bad time, bad time,
Gather in the children
They should not see this.

November 22, 2008.

Oakland, early morning.
So much still to do, so much, so much
When?
So much broken never to be repaired
So much more irreparable.

Sunset.
Oh, the mystery of it
Oh, the mystery of it—
The sunset each day
A luminous fading sign in the sky
To make you cry.

November 23, 2008.
Oakland, morning.
Looking through the January to June notes to make this book of them...[2]
It's all there for the next time that's already now but I don't know it yet—
Streams of small thoughts blowing far down the winds of time.

November 24, 2008.
Oakland, afternoon.
A little bit of music, a charming melody to hold the eye on the thought that hurts
and never goes away.

Late night.
Put the 44 x 30 inch paintings (Oct/Nov) away, re-make the studio space to tell the story of the last years of life... thought by thought, each set in a charming melody to hold the eye through all the centuries to a time when the people of the future write their thoughts over the melodies we have made—

And tonight I told one of my students, "The archetype only wears the clothes of your own space and time, the clothes of <u>you</u>. And you yourself are only a temporary costume laid over the body of everyone forever."

November 26, 2008.
Oakland, very late night.
Oh, oh, oh,
So much time passing
Oh, oh, oh,
The enormousness of it all.

[1] William Blake's "London" from his *Songs of Experience*.

[2] Finally, I added July-December... like this part.

December 2, 2008.
Oakland, no time indicated.
A broken heart, a broken life, all lost.

Heart hurts lying in the memories of times long past will never heal. The wound to one dead long ago lives always on in the mind of the wounder.

Time is only in the mind measured by
the failing of matter and the dying of energy.

December 3, 2008.
Oakland, morning.
Night follows day until one day
Day doesn't come back.

December 8, 2008.
Oakland, early morning.
Wordless speechless emotions—
Days long past and far to come.

Morning.
What is it now
What is it now…

Painting and poetry?
Poetry and painting?

If my work is poetry, don't ask the poets…
If my work is painting, don't ask the painters…

When a youth, I never thought of myself as "youth," only as me. And in maturity, I never though of myself as "mature," only as me. But now the me I think of myself as being is "he is 81," and they say that is old age.

Neither painting nor poetry, my works now are only aphorisms of old age.

December 9, 2008.
Oakland, 2 am.
All the things you learned that you can't use
are going to make you cry,

December 12, 2008.
Oakland, night.
Thinking about how I used to work—
I studied blots on the paper and stains in the street to know what I must learn—
Now it's only the world around me tells me all…
Look and listen, see and sense all around you—
Read it right and it's all you need to know.

December 13, 2008.
Oakland, no time indicated.
Where are you going?
What will you do when you get there?
The studio now is the space I have.
The my life now is the content I have.

The question is, what will I do in the space I have with the content I have?

The Art World?
Not my space, not my content.

A message to the future blown down unknown streets on the winds of times to come?
Yes.

"Great Caesar's bones are dust and clay
Pushed in a hole to keep the wind away"
(Remembered as best I can from a book long lost.)

From a couple of mid December post-its…
Crystalline, crystalline,
Terrifying, terrifying,
Time, time—
The crystal blue sky.

Old men, old women, old people in their late age, send messages to the future—a memoir, a notice, a…
What are these things I make now?

December 15, 2008.
Oakland, morning.
Wake, work, eat and fuck and sleep,
And wake, work, eat and fuck and sleep again
And wake, work, eat and fuck and sleep again
And again and again
And again…

There must be something more.

I told a student that tonight. He only stared at me.

December 20, 2008.
Montreal, morning.
Broken pieces of everything clog everywhere the life of today.

December 29, 2008
Montreal, late night.

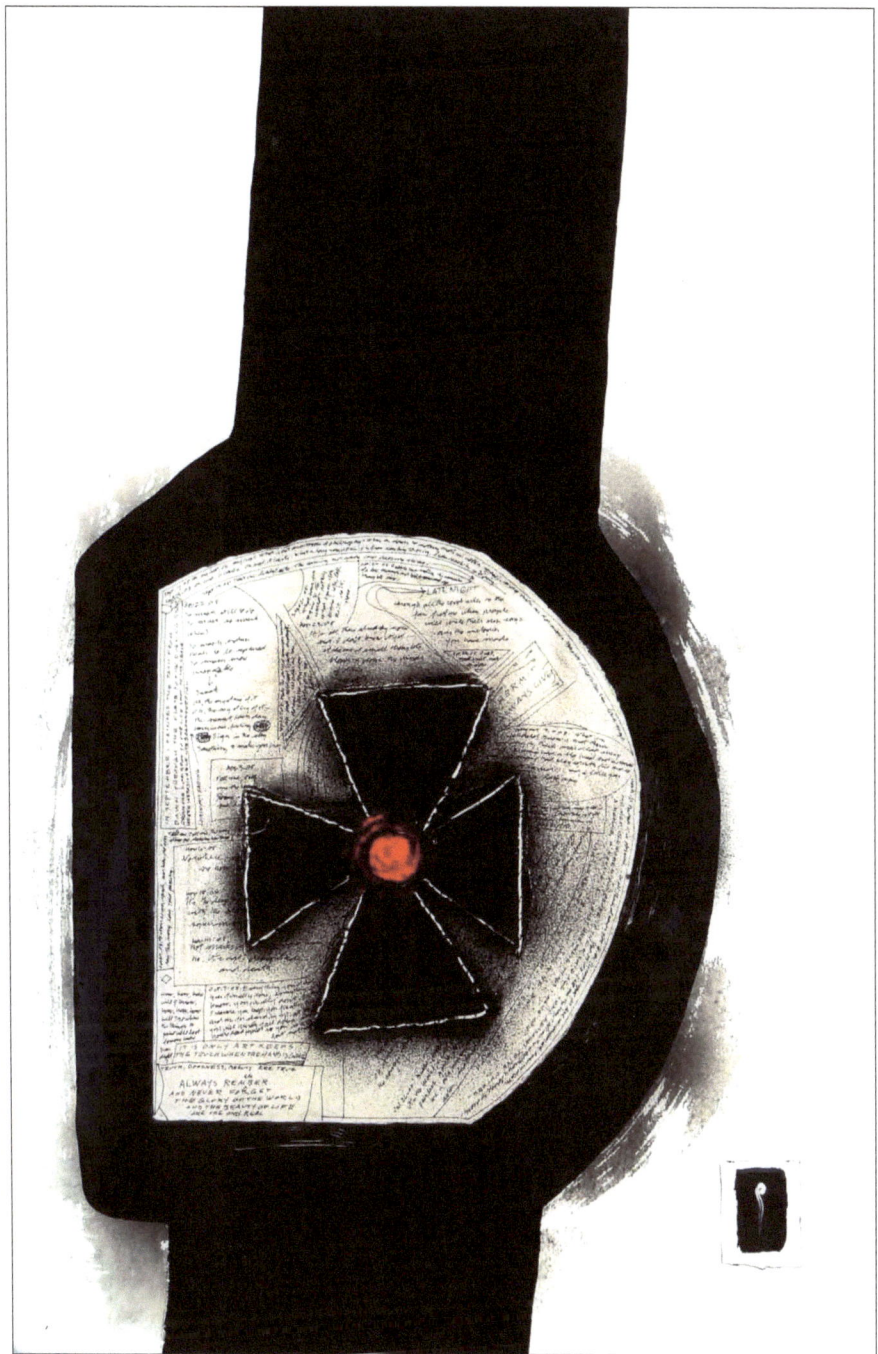

#1 December 2008. 44 x 30 inches.

It's a womb filled with notes from all the months July-December 2008,
with a Death Cross in black but spiraling out of it the red of unconquerable life.
And there's a sperm cell.

If there were a note, it would say "It always takes two."

January 2, 2009.
Lac Ouareau, very late night.
Reading and looking at all the notes for "Where will you go and how will you get there?"[1]
We all know where we are going, and we find out how we got there when we have arrived.

Noticing the program for "Dr. Faust" a couple of years ago in San Francisco and remembering the opera…
Artists try so hard to make their work novel by using formal inventions to make their work new. But formal inventions to make new are always disconnected from the absolutely new of direct personal experience.

So, tell your life, you know no other. And, use formal invention to get flash? None of us are flashy in the soul— just poor beggars living and dying with the most love and the least pain we can get.

January 4, 2009.
Lac Ouareau, afternoon.
Thinking about what to do to start a new painting, looking for some fresh paper by looking in the pile of old stuff leaning against the studio wall, came upon *#22 February 2002*. Trying now to think about what to make of it to tell its truth—make "Old crystals of dead cum dried on the walls of the dirty pink room at the top of the Harrison Street house."

#22 February 2002.

January 4, 2009.
Late night.
Instead of cutting up *#22 February 2002*, I used the Vesalius printouts left over from last August, plus a few comments found in the heap of scraps from last spring and summer to make the first state of *#1 January 2009. "Five bodies and eleven skulls from Vesalius."*.

[1] See #4 August 2008 on page 46.

January 4, 2009.
At the end of the late night (it's really tomorrow).
There you have it, all the cum streaks have a black death streak in them. Damn! Damn! Damn! But, it is what it is. And, the life diamond floats serene above.

January 5, 2009.
Montreal, late night.
#1 January 2009, "Five bodies and eleven skulls from Vesalius." (final state)
I resolved the formal problems in the painting, first by putting in the yellow ochre areas, and second by adding a blood streak in the center of the death streak in each of the cum streaks except the one coming out of the yellow bordered skull in the crotch of Vesalius body #3, the Cuckoo Queer. Yes, his cum is dead, although from his left hand falls a streak of white with a streak of red in it.

January 6, 2009.
Lac Ouareau, late night.
If I knew how to draw it, what would I draw? How much have I new to draw except the past? So far to go, so much to live, so much to make.

January 7, 2009.
Lac Ouareau, night.
Looking at #1 January 2008," Six bodies…"
Body #1 (red skull) is infinite longing.
Body #2 (orange skull) is doing the best I can.
Body #3 (yellow skull) is me Cuckoo Queer
Body #4 (green skull) sums me up.
Body #5 (blue skull) is the hole in the world
 at my end.

What it says on the painting:
"Body fades and dies at last empty hole."

January 4-5, 2009.
Lac Ouareau and Montreal, very late nights.

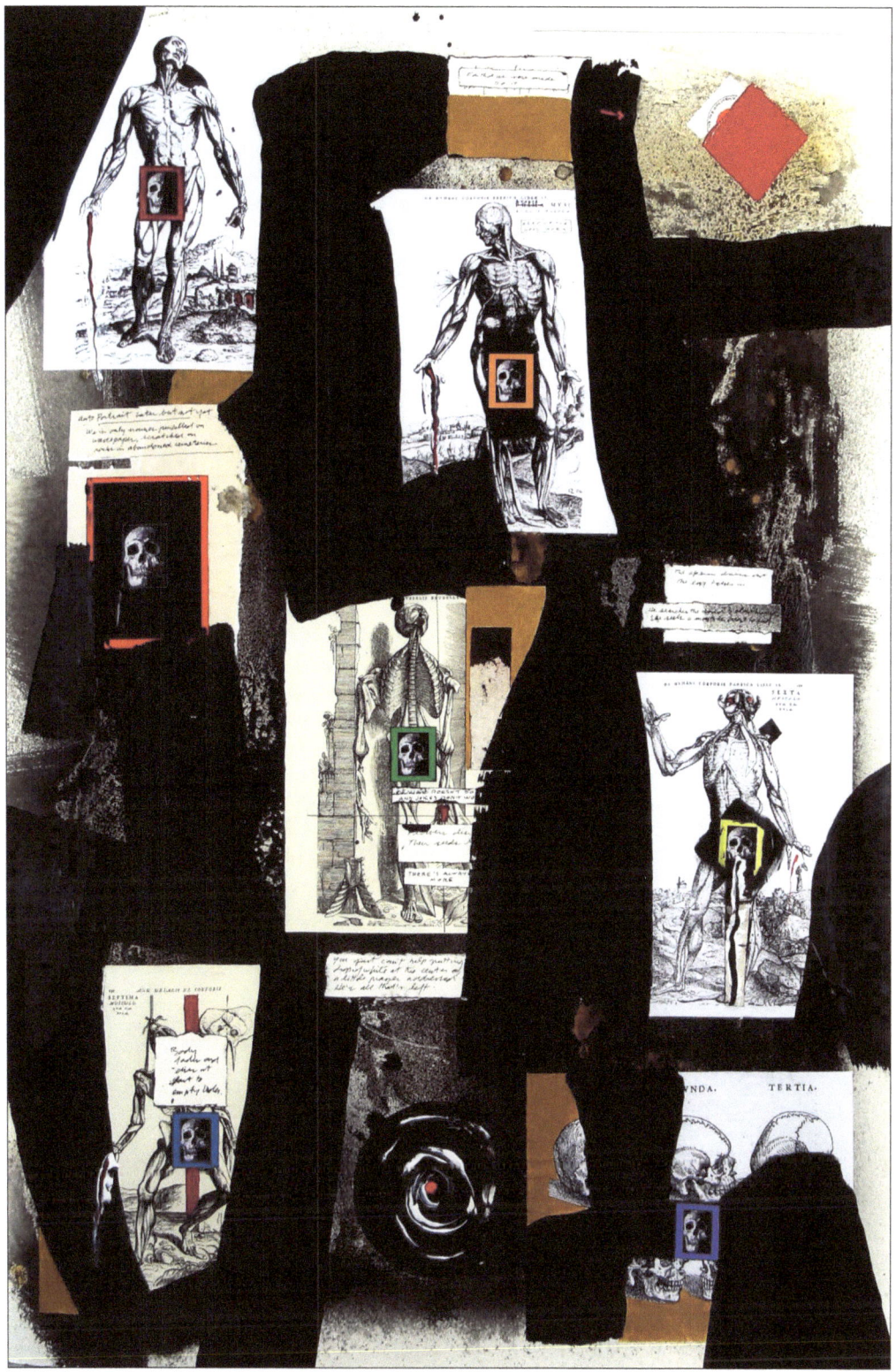

#1 January 2009, "Five bodies and a eleven skulls from Vesalius." 44 x 30 inches.